AN INTRODUCTION TO
PAINTING
PORTRAITS

AN INTRODUCTION TO

PAINTING PORTRAITS

style • composition • proportion • mood • light

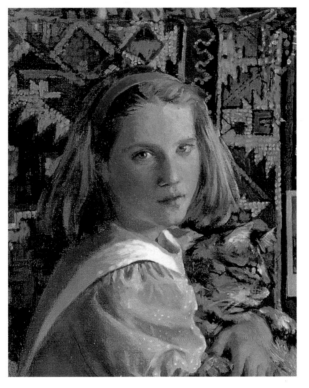

Rosalind Cuthbert

BARNES & NOBLE BOOKS

NEW YORK

This book was designed and produced by
Quintet Publishing Limited
6 Blundell Street
London N7 9BH

Creative Director: Terry Leavons
Designer: Wayne Blades
Project Editor: Sarah Buckley
Editor: Jenny Millington

Typeset in Great Britain by
Central Southern Typesetters, Eastbourne
Manufactured by Regent Publishing Services, Ltd.
Printed in Singapore by Star Standard Industries Pte Ltd.

CONTENTS

INTRODUCTION

So much has happened in the history of portrait painting that it is impossible to give anything but the sketchiest commentary here, but I hope this will serve as an encouragement to look further. You are unlikely to go through life without coming across some of those portraits which are household names – Leonardo's 'Mona Lisa,' Gainsborough's 'Blue Boy,' Hals' 'Laughing Cavalier.' The tradition spans 700 years of Western art. In fact, portrait sculptures were carved by the Romans and Greeks, who also engraved portraits of their rulers on their coins.

Giotto (1267–1337), so the story goes, was discovered, the son of a poor farmer, drawing a sheep on a rock. The famous Florentine painter Cimabue was passing and was so impressed by his natural talent that he arranged for the boy to join his workshop as a pupil. Giotto became the most successful and influential painter of his time and the maker of many great religious masterpieces. The Arena Chapel in Padua, Italy, is a monument to his genius and in the Peruzzi Chapel in Florence is a fresco bordered by almost certainly members of the Peruzzi family. These are sometimes thought of as the first known portraits.

In many early Renaissance religious paintings, portraits of the donors appear as onlookers, perhaps kneeling before the Virgin or standing at the edge of the scene. To begin with they were smaller in scale than the religious figures, denoting their spiritual inferiority, but later, as the donors became more wealthy and influential, their portraits grew to the same scale as the Biblical characters. Humanistic thought was developing at this time and as art developed a secular function, portraiture split away from its religious context and became an art form in its own right. Both Italian and Flemish artists of the 15th and 16th centuries painted bankers and merchants and, from this time onward, portrait painters were employed by kings, popes, and aristocratic families who wanted to celebrate their achievements.

The setting for a portrait and the objects chosen to accompany the sitter have long been a means for the painter to say something more about his subject. From time to time, objects are chosen for their symbolic significance as in the "vanitas" paintings fashionable in the 16th and 17th centuries, in which objects like a lighted candle, a skull, a book and money, prompt the viewer to a melancholy contemplation of the impermanence of life and pleasure. Holbein's *The Ambassadors* (1533) is famous for its anamorphic distortion of a human skull in the foreground. In this painting of two French ambassadors to London, one an aristocrat and the other a young bishop, between whom are displayed accoutrements of their intellectual and spiritual achievements, the skull is an uncanny reminder that all must perish.

RIGHT Hans Holbein, *The Ambassadors* (oil on canvas), 48 x 36in. *Reproduced by courtesy of the Trustees, The National Gallery, London.*
This exquisite painting is one of many done by Holbein in his late period. Note detailing on the fabric and hands.

OPPOSITE PAGE Juliet Wood, *Emily Brett* (oil on canvas), 15 x 12in.
In this little portrait the burnt sienna underpainting is allowed to break through, enlivening the cool passages. Juliet finds that a little cold pressed linseed oil added to the paint helps it to go on smoothly, even over a surface which has already dried.

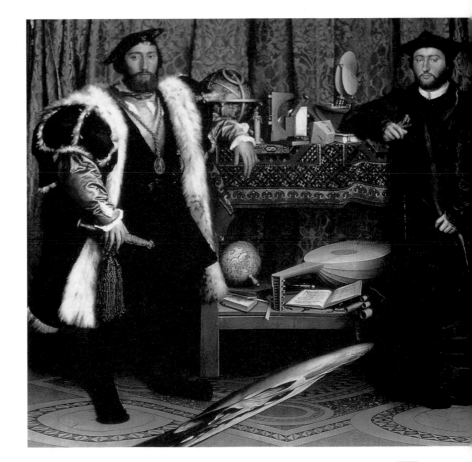

Jan Van Eyck (1390–1441), the great 15th century Dutch painter, filled his religious pictures and his portraits with objects carrying a symbolic interpretation. Much has been written about his painting *The Arnolfini Marriage* (1434). The little dog at the feet of the couple is said to symbolize fidelity, the oranges fertility. The couple have removed their sandals indicating the sanctity of the occasion. The light enters through a large window yet a single candle burns in the chandelier behind and above them. This is a portrait which also tells us about the couple's tastes, beliefs, and status.

Most, if not all, society portraiture celebrates wealth, charm, and power. Official portraiture celebrates power and achievement. These forms are usually commissioned and almost always closely follow traditional lines.

There is of course another type of portraiture, the informal portrait. These are often intimate insights into the psychology of a friend, relative, or lover. Goya's *Maja* paintings, Stanley Spencer's portraits of Hilda, Monet's portrait of his dying wife, and Paula Modersohn-Becker's portraits of old women and children, to name a small handful in a wealth of portraits of this type. Portraits like this are usually uncommissioned and in recent art history it is more this kind of portrait that we know and love. The portraits of Gwen John, Van Gogh, Cézanne, and Picasso are just a few very familiar names.

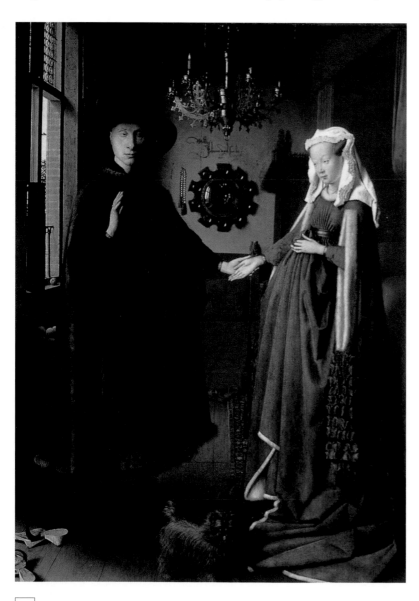

LEFT *T**he Arnolfini Marriage*** – **Jan Van Eyck, 1434 (32 x 23in.) National Gallery, London.** *Reproduced by courtesy of the Trustees, The National Gallery, London.* **Popularly thought to be a marriage ceremony, although this is by no means certain. This painting seems surprisingly modern in its portrayal of light, which subtly unifies all the objects and figures in the room, giving an illusion very close to our own contemporary experience.**

Some portraiture is highly imaginative, stylized, or distorted, and artists such as Francis Bacon wrest a likeness from the sitter by a tortuous painterly process, producing great art as well as great portraiture – perhaps a portrait of our times as much as an individual likeness.

Bacon is an unusual example of a portrait painter who never worked to commission. Amazingly, Bacon's paintings are recognizable likenesses of his sitter, a necessary condition of a portrait.

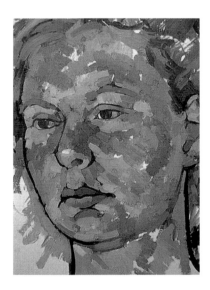

ABOVE Robert Maxwell Wood, *Head lit from below* (oil on canvas), 16 x 12in. In this study you can see how Max models a head with color using short brush strokes, having first used an ultramarine underpainting.

RIGHT Jack Seymour, *Jean* (oil on board), 22⅞ x 15in. In a profile view the ear is the center of attention while the other features hug the contour. Notice that the eyebrow touches the profile but the eye is set back from it. When painting this view it is important to observe correctly the gradient of both eyebrow and eyelid as well as that of the mouth. The neck is not vertical, but angled forward.

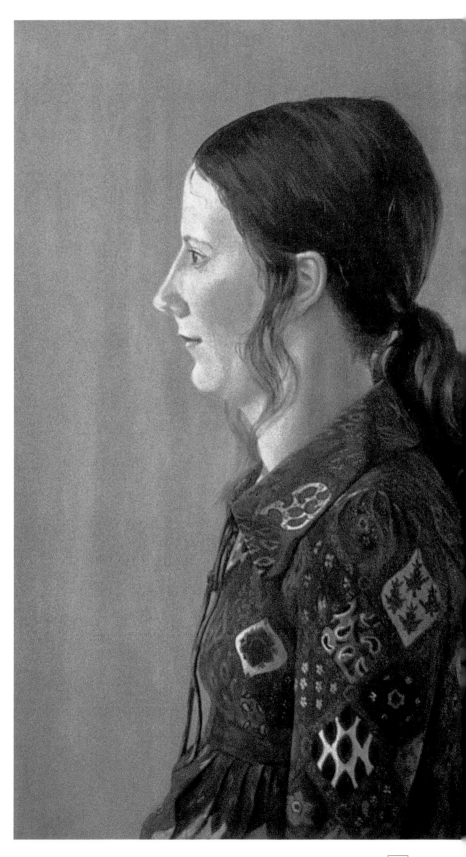

The question of what makes a good likeness is impossible to answer. If ten painters gathered around a single sitter their differing styles might produce radically different images, each of which might also be a good likeness. Assistance with finding a likeness will be found in the early chapters of this book, and the importance of drawing cannot be overstressed. Regular practice with pencil, conté, or charcoal will help train the eye and develop fluency of line which will translate into fluency of the brush in painting. It is always educational to study the drawings of the great master painters.

As to which medium might be best for you – if you have a natural predilection, simply follow it and experiment as you go,. If not, perhaps colored soft pastels would be a good medium to begin with as they are easier to control than paint and in their handling lie somewhere between drawing and painting. Hopefully, chapters 10 and 11 on media will help you to decide.

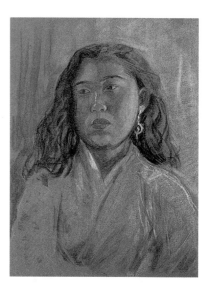

RIGHT David Cuthbert, *English Odalisque* (acrylic on paper), 30 x 22in. The largest and most striking areas of tonal and color contrast are in the figure. The remainder is mostly broken up by smaller brushmarks denoting patterned fabrics. Touches of bright green and blue provide relief from the rich reds and purples. The composition and pose combine steep and gentle diagonals – nothing is quite horizontal or vertical.

ABOVE Ros Cuthbert, *Mao* (pastel), 30 x 20in.
I often do a pastel study before beginning an oil painting. Here, I first drew with charcoal and then worked broadly but lightly in color, allowing the orange-brown paper to remain visible.

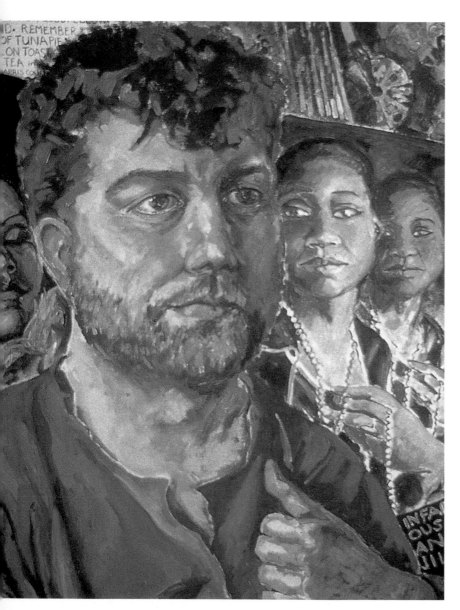

LEFT Stina Harris, *Portrait of Ian Clayton* (oil on canvas), 36 x 30in.
Here, the beard and hair are quite different colors and textures. Notice how the beard blends into shadow under Ian's chin.

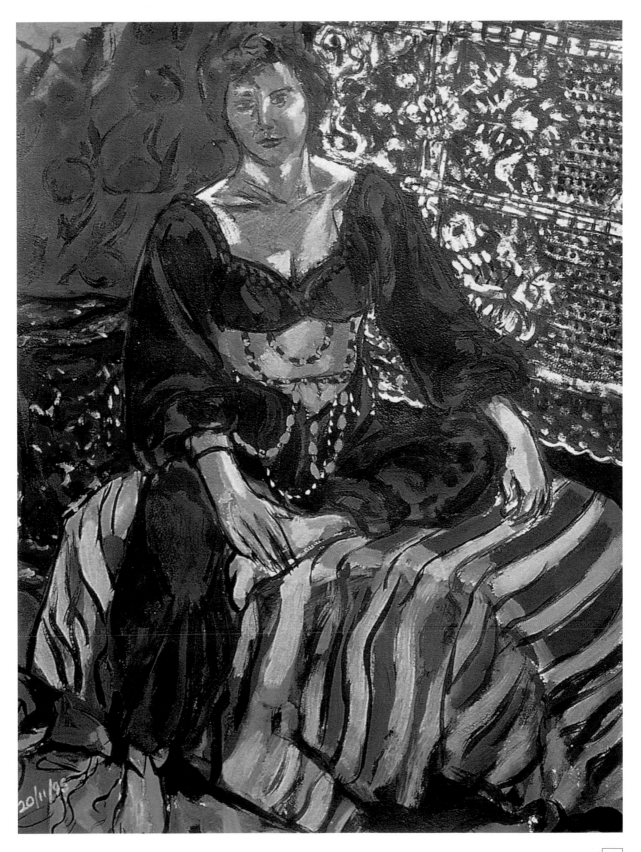

1

PROPORTION, FORESHORTENING, MEASURING

RUSKIN SPEAR DEFINED A PORTRAIT AS A LIKENESS OF SOMEONE, BUT WITH THE MOUTH NOT QUITE RIGHT. THIS IS AN AMUSING WAY OF SAYING THAT PEOPLE TEND TO HOME IN ON DETAILS WITHOUT UNDERSTANDING THE UNDERLYING FORMS OF THE HEAD AND FACE. IN THIS CHAPTER, I WILL GIVE SOME GUIDELINES WHICH WILL HELP YOU TO LINK THE FEATURES TOGETHER AND SEE THEM AS PART OF A WHOLE. AS RUSKIN SPEAR HINTS, THIS APPROACH IS ESSENTIAL TO OBTAINING A GOOD LIKENESS.

PROPORTION

We will begin by looking in a generalized way at the proportions of a typical human body. For this a useful unit of measurement is the head-length. A typical adult male stands about seven-and-a-half head-lengths tall, a female seven head-lengths. Babies and children have larger head-lengths in relation to their bodies. At birth the baby measures about four times its head-length, at five years old, six times, and at nine years old about six-and-a-half times. The head of course grows in size too, but at a slower rate.

Other points worth noting are firstly, that the center of the body is at the pubic bone, not at the navel as most people think. The elbows are in line with the waist and the fingertips fall level with the lower middle of the thigh. The knee comes midway between heel and hip.

A man's shoulders are about two head-lengths wide, his hips are narrower. In a woman, the shoulders are proportionally less wide, and the hips wider than a man's.

In a typical adult head the eyes are about halfway from chin to top. Many beginners get this wrong and make the eyes too high and the forehead too small, so check this carefully at the outset of a drawing. The inside corner of the eye lines up with the outer edge of the

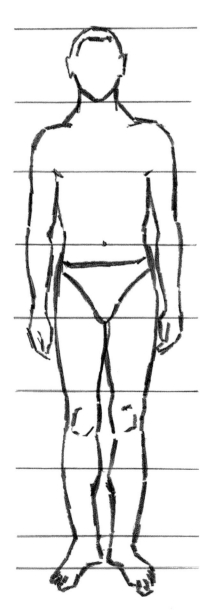

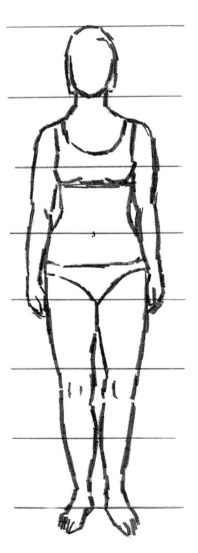

LEFT Two drawings showing the typical proportions of (left) an adult male and (right) an adult female.

OPPOSITE PAGE David Cuthbert, *Study of Herbert* (acrylic on paper), 30 x 22in. This unfinished study was painted quickly and broadly. We can see the relationship between linear brushwork seeking out the rhythms and structure of the likeness, and tonal shading exploring the play of light.

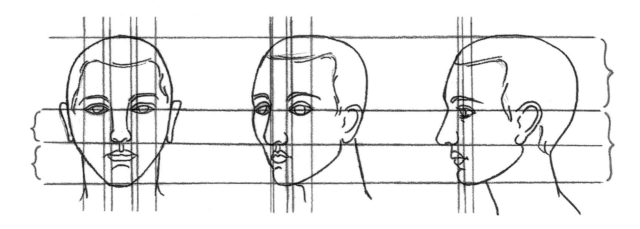

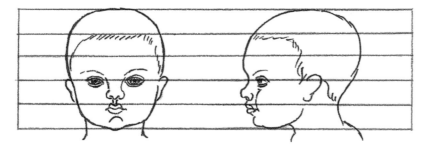

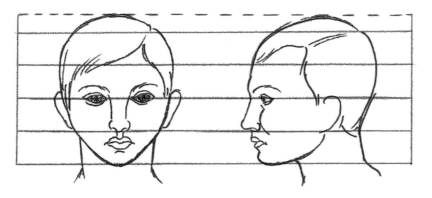

ABOVE Three drawings showing (left) the proportions of a typical adult head, (center) the effects of foreshortening in a three-quarter view, and (right) a profile view.

LEFT Two drawings showing the proportions of (top) a new-born baby's head and (bottom) the head of an eight-year-old child.

OPPOSITE LEFT Ros Cuthbert, *Tomasin at six weeks* (oil on canvas), 42 x 27in. This painting, done from life, shows just how small an area is occupied by the features in the head of a very young child. Compared with many babies, Tomasin was long-limbed – she is now, at 16, nearly six feet tall.

OPPOSITE RIGHT Jerry Hicks, *Lara* (oil on board), 48 x 19in. This little girl stands five-and-a-half head-lengths tall. Her knuckles are halfway between her shoulders and her feet. She is eight years old.

nostril on a vertical axis and, again on a vertical axis, the corner of the mouth lines up with the inner corner of the iris – if the person is looking straight ahead. The lower part of the face from chin to base of nose measures about the same as the area from base of nose to a point between the eyebrows above the bridge of the nose.

On a horizontal axis, the eyes are usually separated by a further eye's-width across the bridge of the nose. Also, the ears are generally on a level with the nose, though this generality is often very different in the flesh. Notice in the diagrams how small a space on the total surface area of the head is taken up by that triangle created between the corners of the eyes and the chin – less than one eighth of the whole. And look too at how much expanse of cheek there is between this triangle and the ear, especially in the profile view. Another common

error is for the ear to be drawn too close to the eye – or else too far away. When we look at each of the features in later chapters, I will deal much more with the business of placing them in relation to the whole head.

The three-quarter view is very common in portraiture as it provides us with the most information about a sitter's face. In a three-quarter view the features are foreshortened across the front

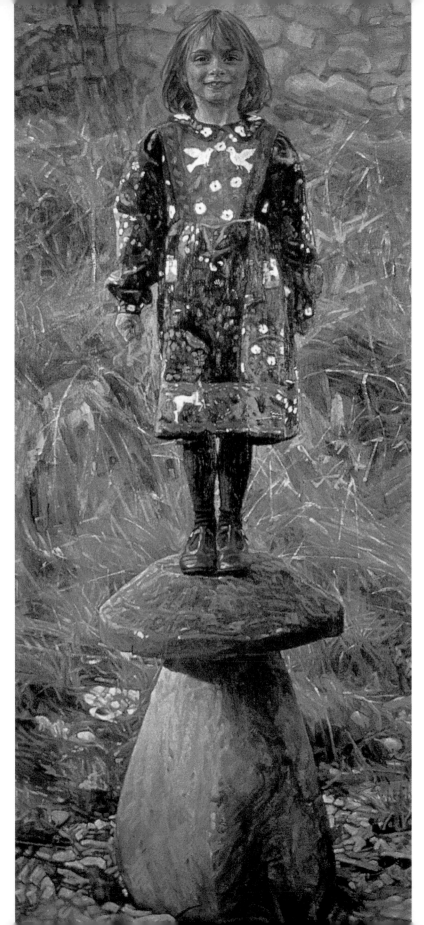

of the skull, which is not flat, but curves away toward the ears. The main difficulty you may have with this view is in correctly observing this effect.

Before leaving the subject of proportions I should say that in babies and children things are somewhat different. In a very young baby the features are even smaller in relation to the whole head. Thus, the eyes are set perhaps two-fifths up from the chin, three-fifths down from the top of the head. The eyes are wider apart, but this does not mean that they are closer to the sides of the head – on the contrary. The space between outer corner of eye and side of head is likely to be broader in relation to the eyes than it is in an adult. The baby's head is covered with a layer of fat which softens its contours and gives it a rounder appearance. As a child grows its skull lengthens and the features become larger. The nose begins to take on its adult shape and the mouth lengthens and loses its rosebud roundness.

ABOVE **Three drawings showing (left) the head looking forward, (center) the head tilted down, and (right) the head tilted up.**

FORESHORTENING

The second part of this chapter deals with the effect of fore-shortening of the features when the head is turned away, tilted or viewed from above or below. We have already seen that the face is set into a curved surface and that as it turns away from us the features undergo quite dramatic changes in appearance, the far eye, cheek, and side of the mouth becoming compressed. When viewed from above or below, things are also somewhat altered. The effects are easy to see in a mirror. If you tilt your head down and look at yourself from under your eyebrows, you will notice first of all how much more of the top of your head is visible and how much less of your face: the whole face becomes foreshortened. The nose may overlap the mouth, the chin disappears, and most dramatically of all, the ears are suddenly much higher than the nose. In an upward tilt the reverse happens. The ears drop low, the top

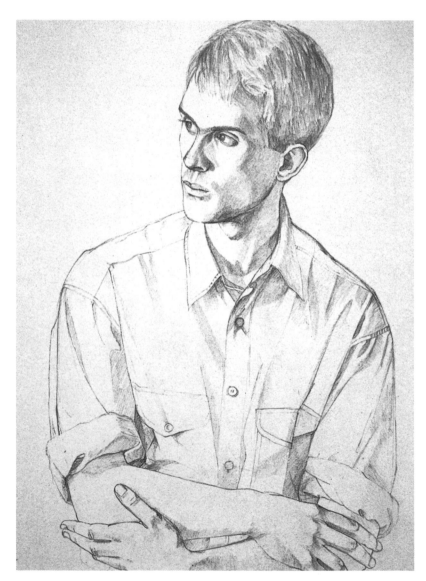

RIGHT Ros Cuthbert, *The Reverend Alan Grange* (oil on canvas), 60 x 42in
I sat quite close to my subject for this portrait. His knees and feet were much closer to me than his head. The result is that his head appears relatively small while his shoes are exaggeratedly large.

BELOW Robert Maxwell-Wood, *Resting man* (charcoal and pastel), 16½ x 12in.
Here is an example of extreme foreshortening of the head of a man lying down. From chin to eyebrow his face occupies only one-third of the whole head. His mouth has all but vanished behind his nose. Because his eyes are closed we see the whole of his upper lids. The ear is foreshortened – we are viewing it, as it were, from above.

LEFT Ivy Smith, *Simon Mills* (pencil drawing), 28 x 22in.
In this portrait, Simon's head is both turned and tilted. As we are looking slightly down on his face, the top of his head is turned more toward us and the space between his eyebrows and eyes has almost disappeared. Because his head is turned away we can see the whole of his cheek, from nose to ear, as well as the side of his nose. His far eye is partly eclipsed by his brow and nose, and the far side of his mouth is turned steeply away from us, compressing its shape. Notice that because his head is also tilted, the eyes and mouth are now set at an angle, no longer parallel to the floor, and his ear is lower than his nose.

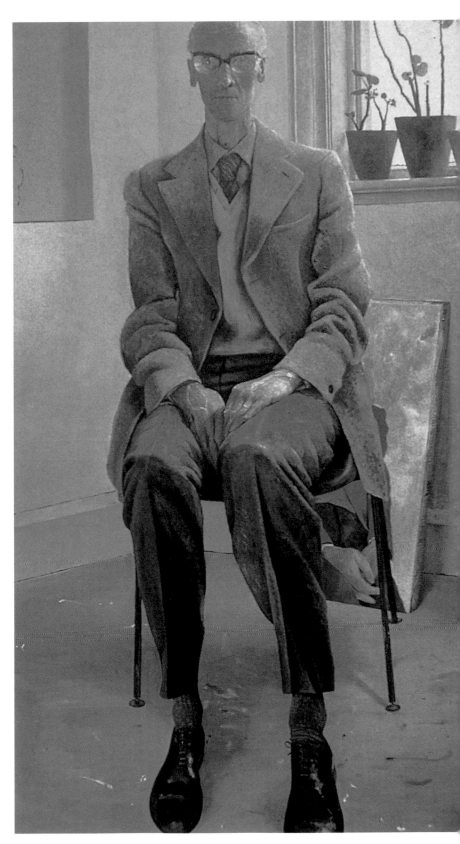

of the head disappears, you seem all throat and neck, and the features are foreshortened in the other direction, showing the under arch of the eyes, underside of the nose, and an exaggeratedly wide upper lip and narrow lower lip. The mouth curves much more steeply downward.

These are extreme examples of a much subtler effect in most portraiture, but should your sitter's eye level be higher or lower than your own, you need to know the effects this will have on what you are seeing. After all, it is usual for a sitter's head to be tilted or turned in some way. We will go into the effects of foreshortening more deeply in later chapters on the features.

MEASURING

There is an important way of checking your drawing as it progresses and also of constructing it in the early stages, and that is by measuring. The third part of this chapter deals with this. If you know how to check for mistakes as they occur you will make much faster progress. Even experienced portrait painters check their work in this way.

The system I shall explain here does not involve measuring in inches. You begin by simply holding a pencil vertically in front of your model. Making sure your arm is fully extended and, if necessary, supported at the elbow to prevent it from wobbling, move the pencil tip until it is level with the top of your model's head. Close one eye or you will see two pencils. Now, move your thumb up the pencil until the top of it is level with the bottom of your model's chin. This gives you one head-length marked out between pencil tip and thumb tip. Next, move the

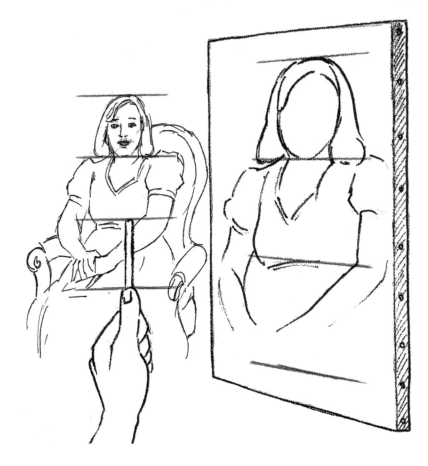

ABOVE **Drawing showing the artist measuring the model and enlarging the scale to fit the canvas.**

pencil down until its tip is now where your thumb was. You should be able to see your thumb's new position one head-length lower. Making a mental note of that spot, lower the pencil again to mark off a third head-length and so on, continuing until you have covered the whole pose from top to toe. Perhaps the pose occupies five-and-a-half head-lengths.

Next comes the problem of transferring this information to paper or canvas. You must remember that unless you want to paint a sight-size portrait (in other words, a portrait that appears, from where you are, to be exactly the same size as your model) you will need to scale up or down the unit of measurement. How large or small you make it is up to you, according to how you want to place

your subject within your painting. The best way to decide is to divide your picture surface into, say, five-and-a-half equal units, leaving enough room at top and bottom or you will find your subject touching the top and bottom edges of your paper. Each unit represents a head-length. The diagram above demonstrates how to follow this method to transfer scale to fit.

Once you are used to marking off head-lengths in this way you will find it easy to use other sections of the pose to make checks both vertically, horizontally, and diagonally – in fact in any direction necessary. For instance, a head-length can be turned on its side

(turn the pencil, thumb in position, through ninety degrees until it is horizontal) and used to check the width of the pose, the position of an elbow or hand, or the length of an arm.

If drawing a head, you should likewise be able to find the unit of measurement which is most useful and scale it up in the same fashion. To start with, I suggest you plot the position of the eyes in relation to the head's length by measuring the top half (top to bridge of nose) against the bottom half. An eye or nose-length is another useful unit of measurement.

This chapter has aimed to give you a good working knowledge of proportion and foreshortening and a means of steering yourself through the process of looking and recording. The next step is to do as much drawing from life as you can. Ask family and friends to sit for you or use your own reflection in a mirror. Don't try to paint a portrait before you can draw one confidently. If possible, join a portrait or life class and take a sketchbook down to a bar, on to the beach, or into the park to find subjects. The more confident you become, the easier this will be. I have drawn strangers on buses, trains, airplanes, on park benches – in fact wherever I have found myself with time to spare with a pencil and a small sketchbook in my pocket.

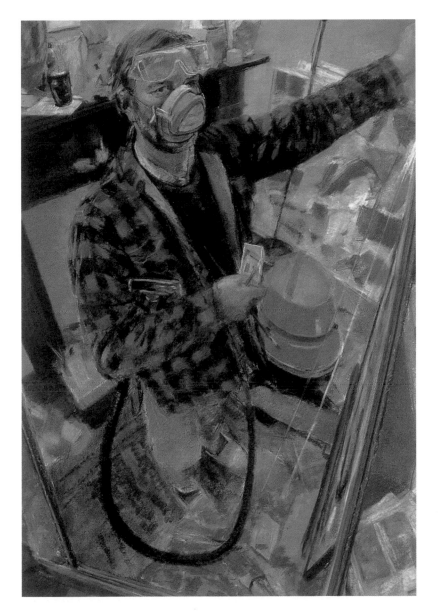

LEFT Barry Atherton, P*astel painting*: A *self portrait* (pastel on hand made paper laid on wooden panel), 44 x 30in. The extreme foreshortening of this picture greatly reduces the number of head lengths in the subject's height. His head and arms appear large, while the legs taper rapidly to a pair of tiny feet. Forms diminish quickly as they recede in space.

2
LIGHT AND SHADE

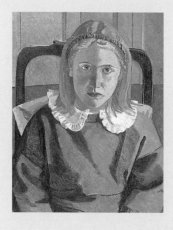

C APTURING A LIKENESS WITH LINE ALONE IS PERFECTLY POSSIBLE, BUT THE NEXT STEP IS TO MODEL A HEAD IN LIGHT AND SHADE. DEGAS SAID TOWARD THE END OF HIS LIFE THAT IF HE COULD LIVE IT AGAIN HE WOULD PAINT ONLY IN BLACK AND WHITE. TO MOST OF US THIS MAY SOUND LIKE SOME KIND OF PENANCE, BUT IT DOES SHOW JUST HOW IMPORTANT LIGHT AND SHADE ARE TO A PAINTER OF THE HUMAN FIGURE, AS WELL AS SUGGESTING THE WONDERFUL POSSIBILITIES OF PURELY TONAL PAINTING, SOMETHING ALBERTO GIACOMETTI WAS SUPREMELY AWARE OF AND IT IS CERTAINLY EASIER TO EXPLORE THE SUBTLETIES OF TONE WITHOUT, AT FIRST, HAVING TO WORRY ABOUT THE COMPLEXITIES OF COLOR.

RIGHT Robert Maxwell-Wood, *Woman in Black and White* (oil on canvas), 16 x 12in.
In this strongly modeled head, the brush strokes follow the direction of the forms. The thick paint suggests sculptural solidity, while black linework is allowed to break through the overlaid mid-tones or is laid into the wet paint to redefine the drawing.

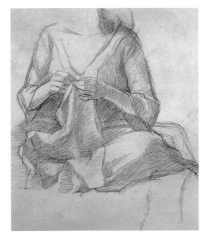

ABOVE Juliet Wood, *Study of Lara* (pencil), 22 x 15in.
This line drawing has been developed into a tonal study that captures the light on Lara's moving fingers. Darker shades have been crosshatched.

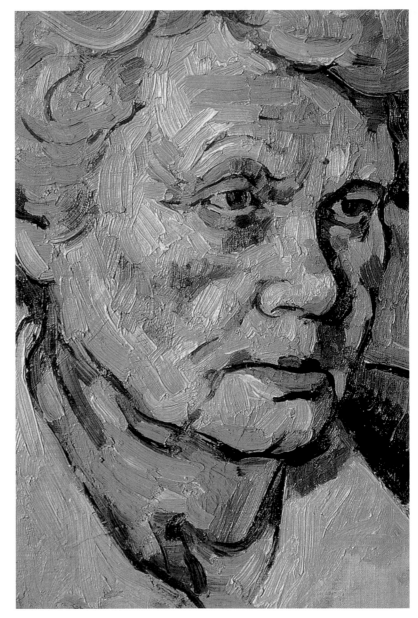

LEFT Ivy Smith, *Portrait of Hattie* (oil on canvas), 22 x 20in.
Another girl in pink. This time the subject is more strongly lit. Painting thinly on a white ground, Ivy has obtained maximum luminosity of the colors. The bright pink sweater has thrown back reflected color on to Hattie's nose and chin. As in Jane Bond's painting of *Laura*, the background is more flatly lit than the figure, enabling bright colors to be used without overpowering the subject.

When light illumines the surface of any object it also creates shade. If the light is soft and diffused the shadows will also be soft and there may be no great difference between lit and unlit parts of a head. But if a bright light is shone on to the side of a face it will dramatically illuminate it, casting the other side into deep shadow. The way your subject is lit is very important in deciding the mood of your picture and also of your sitter – and it is wise to give yourself a thorough grounding in observing and recording these effects. Pencil, conté, or charcoal studies should become a part of your weekly or daily routine until you are confident of your technique, and then be followed up with tonal studies on mid-toned gray paper using black or raw umber, and adding highlights with white chalk.

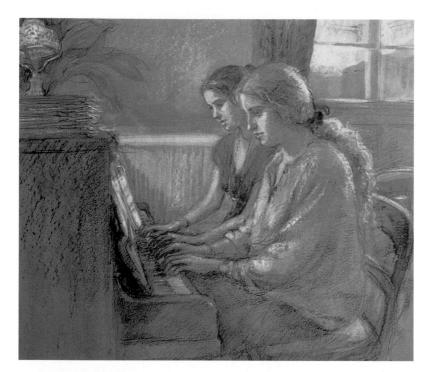

LEFT Rachel Hemming Bray, *Kate and Annabel playing duets* (conté, charcoal, gouache and pencil), 14 x 17in.
In this drawing there are two sources of light. The main one illumines the girls and the keyboard, creating a pool of light surrounded by shadow. Daylight filtering in through the window forms a second source, lighting up the nearest girl's long hair.

BELOW Ivy Smith, *Kay reading* (oil on canvas), 36 x 48in.
In this portrait the main light source is out of the picture – a window, which lights Kay's hands and book, and also her face. Behind her, a glass paneled door admits light on to the subject's hair, and on to the floor so that her legs appear backlit. This ingenious use of a double light source emphasizes the subject's solidity as well as providing some beautiful passages of light/dark counterpoint, her face appearing light against a darker wall and her legs dark against a bright floor.

LIGHTING YOUR MODEL

Most portraits are painted indoors and usually the sitter is placed near a window facing north or at least out of direct sunlight. The softness of natural light is very beautiful and light filtering through a window on to a face will disclose its qualities gently and truthfully. Rembrandt lit his subjects from a high angle producing a spotlight effect, while Holbein favored light entering at a level close to that of his sitter's eye-level, as in his marvelous portrait of the German merchant, George Gisze (1532). North light is also natural light at its most constant and that is why artists are often careful to choose a north facing room for a studio, or to fit north facing roof lights.

Direct sunlight is a problem for portrait painters as it sharpens tonal contrasts and also because it is never still. It is possible to paint from life in direct sunlight but I would advise you not to try it too soon. Wait until your skill has increased and you are able to complete a portrait quite quickly. There is nothing more frustrating than to be halfway through a portrait and find that the light has changed, altering all the color relationships; and even a small shift in the light is enough to create confusion.

I will say a word or two about working from photographs at this point because it is an obvious way of making a painting of, say, a girl under a tree with dappled light on her. If you are taking a photograph of a subject you know you will want to paint, it is best to take several photographs and not rely on one. If you have a manual control camera, alter the aperture to take in more, and also less light than your light

meter indicates, in case your sunlit areas suffer from burnout, or your dark shadowy areas come out black in the photo. It is very likely that one or other of these will happen and it is difficult to imagine the colors that your camera has not picked up, but which your own eye most certainly would have seen. In general, I do not recommend

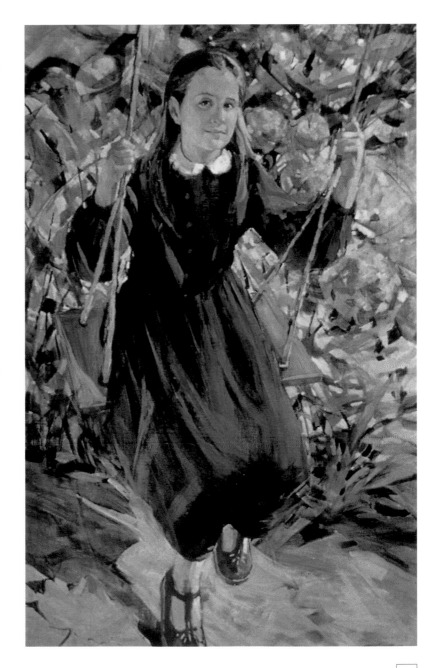

BELOW Ann Hicks, *Girl on a swing* (oil on board), 36 x 24in.
This is a delightful, freshly painted picture. The light reflecting up from the ground illumines the girl's dress and her skin which, on the shadow side, acquires a bright yellowish tint. The painting is full of light and movement, an effect obtained as much by spontaneous brushwork as by the subject matter.

working on a portrait from photographs until you have gained a great deal of experience working from life, as the pitfalls are many. But I discuss this more in the chapter Photography and Group Portraits (page 112).

The beauty of sunlight is that it increases the amount of reflected light, bouncing back on to your sitter's face from surrounding sunlit surfaces. Something of this effect can be achieved indoors using artificial light. A single light source can be rather dull, flat or colorless. I was once painting in a large white room lit by only one window where this was the case. I introduced a "floor spot" light on the same side of the model as the window and hung a yellow drape on a screen on

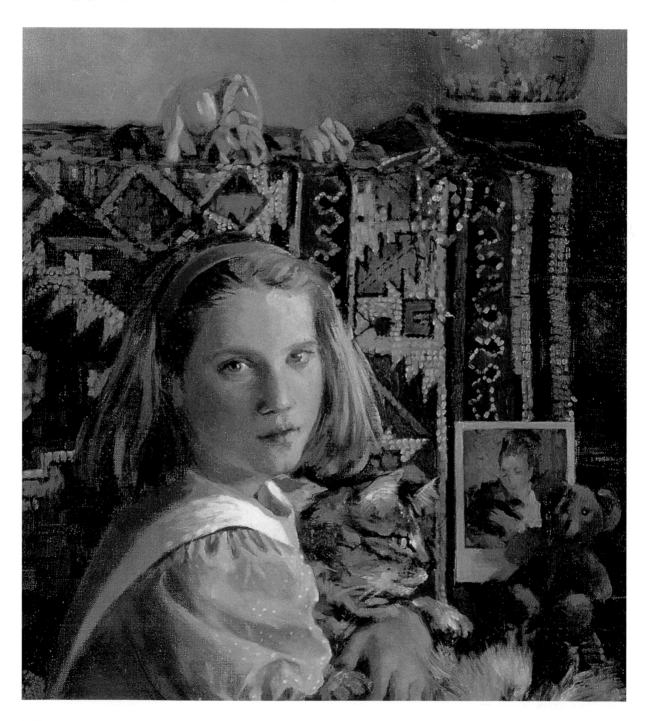

the other. The effect was to transform the subject and lift the whole mood of my painting. Warm golden light bounced into the shadows, pulling out of the existing gloom previously invisible forms and contours.

DOUBLE LIGHT SOURCES

Another possibility is to use two light sources. A favorite device of mine is to place my sitter near a window and shine on his or her dark side a small table light, one which can be angled to give just as much or little additional light as I need. Natural north light is cold but artificial light often quite warm, producing golden or honey-colored hues. Sunlight, too, produces warmer colors than north light. This warm-cool light contrast provides wonderful opportunities for a varied palette. I will discuss this further in the chapter Painting Skin Tones (page 40).

THE FINISHED EFFECT

I should say that a double light source is rarely found in what one might loosely call traditional portraiture. Until the Impressionists discovered the joy of working outdoors, the convention was to employ a single light source in a portrait. It is true that this produces a simpler effect which can probably be read by the viewer at a greater distance, an important consideration in large scale public or corporate portraiture, or where the portrait has to be hung in a spacious room. It displays the features and character of the sitter so that they can be accurately recorded and avoids all kinds of difficulties

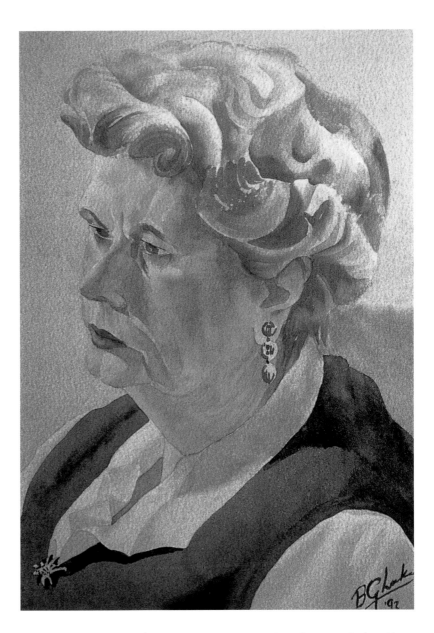

OPPOSITE PAGE Jane Bond, *Laura* (oil on canvas), 23 x 21 in.
The child and her cat are softly lit, probably by natural light coming through a window. They are painted in brighter, lighter tints than the background. In this way the artist avoids overpowering her sitter's young face with the heavily patterned carpet.

ABOVE Brian Luker, *Portrait of an old lady* (watercolor), 16 x 12 in.
Lit slightly from behind, the nose and mouth cast shadows across the cheek and chin toward the viewer, giving a strong sense of form.

RIGHT Jerry Hicks, *Kim's summer hat*
(oil on canvas on board), 48 x 36in.
Here is another subject lit by sunlight.
Because the light is coming from
behind, Kim's face is in shadow.
Reflected light from her dress plays on
her face and throat which, along with
her arms, are otherwise predominantly
a cool bluish pink. This contrasts with
the warm peachy light on her shoulders.
Where the dress is in shadow the
greenish tints were probably suggested
by light reflected up from the grass.

ABOVE Hugh Dunford-Wood, *Emma*
(oil on canvas), 40 x 25in.
The features of this woman are strongly
lit by a single light source entering from
her right. Light reflecting back on to her
dark side from the white top outlines
her jaw and nostril. The starkness of the
light and the full face pose create a
powerful sense of presence.

OPPOSITE Jerry Hicks, *Bunny*
(oil on board), 36 x 28in.
In this beautiful painting of a young
man the dappled sunlight and his
relaxed, dreamy expression create a
warm and gentle atmosphere. Note the
honey-colored reflected light from his
chest under the chin, nose, eyebrows,
and also on the upper lip.

presented by a double light source,
such as differing color temperatures
on either side of the face and, in
extreme cases, where a face is lit
equally from both sides, a dark
central panel. Light sources crossing
on a face produce all kinds of effects
which can be difficult to analyze.

Although a commissioned
portrait is usually conventionally
lit, when painting portraits for
pleasure we are free to experiment
and it is fascinating to see how
unusual lighting can transform a

face. Occasionally we come across a
portrait employing a strong
overhead light or which is lit from
below, such as Degas' portrait of
the singer Thérésa in full flow. He
was fascinated by the stage lighting
and painted its effects many times,
on singers and dancers.

The light on your subject is
important, but so too is the light in
the background. Arrangements of
light and dark make a huge
difference to the impact of a portrait.
More of this in the next chapter.

3

COMPOSITION

AND DESIGN

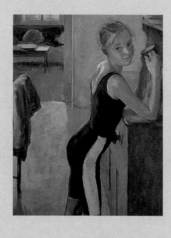

THE FIRST HURDLE IN DESIGNING A PAINTING IS TO BE ABLE TO PLACE THINGS EXACTLY WHERE YOU WANT THEM. IT IS NO GOOD DOING A BEAUTIFUL PORTRAIT IF THE HEAD IS TOO LOW IN THE PICTURE, LEAVING A SURFEIT OF FRESH AIR OVERHEAD; OR IF THE HANDS OR FEET ARE CUT OFF AWKWARDLY OR WORSE STILL, SQUEEZED IN SOMEHOW. THIS IS AN ASPECT OF DRAFTSMANSHIP WHICH HAS ALREADY BEEN DISCUSSED IN CHAPTER 1 BUT IF YOU HAVE DIFFICULTY WITH IT, IT IS WORTH PRACTICING JUST THE BUSINESS OF PLACING A FIGURE, OR A HEAD, SO THAT YOU ARE IN CONTROL WHEN IT COMES TO DESIGNING A PAINTING. MEASURING IS A USEFUL TOOL HERE.

SIZE AND SHAPE

In the planning stages of a portrait, I usually make a few quick sketches before deciding on the size and shape of the support. (If it is a commission these things will be discussed with the client.) The usual shape for a portrait is a vertical rectangle but the height in relation to the width is an important consideration. If I am satisfied with a composition sketch, I enlarge it by extending the diagonal until I find the most appropriate dimensions.

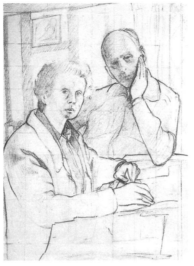

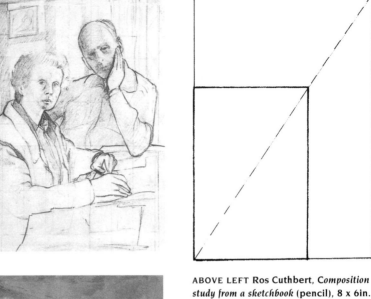

ABOVE LEFT Ros Cuthbert, *Composition study from a sketchbook* (pencil), 8 x 6in.

ABOVE RIGHT This diagram shows how a small drawing or photograph can be scaled up by extending the diagonal. The ratio of width to height remains the same.

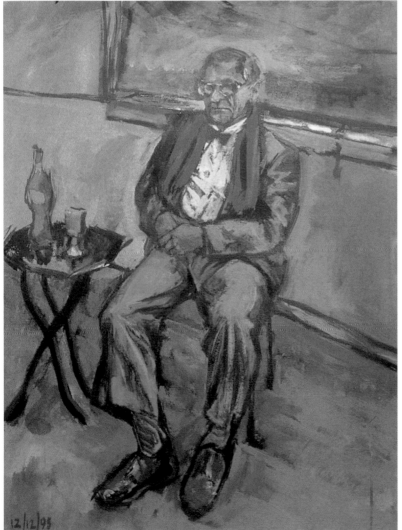

LEFT David Cuthbert, I *suppose it's my round* (acrylic on paper), 30 x 22in. Reminiscent of Sickert, this portrayal of a man drinking at a table is pervaded with a kind of "ennuie," despite the bright coloring. The pose is awkward, with one shoulder raised and the other lowered, while the knees, raised and lowered the other way around, underline the imbalance. On the man's left, the orange wall is picking up color from an artificial light, while on his right and around the table, cooler natural light is interpreted as pink.

OPPOSITE PAGE Juliet Wood, *Emily in cycling shorts* (oil on canvas), 28 x 18in. In this informal study, Emily's body forms a steep diagonal as she leans towards the edge of the picture, leaving half the picture free for the view through two rooms and into the garden. The colors of her green and black shorts are repeated in the top left corner. Varying shades of green brushmarks woven into other colors suggest light and coolness.

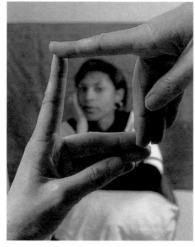

ABOVE A homemade viewfinder. More
simply, fingers used as a viewfinder (right).

Another useful hint is to make a
"viewfinder" by cutting out two
L-shaped pieces of thin card and
fixing them together to make a
rectangular hole. Use paper clips so
the hole can be altered in shape. By
looking through this hole at the
subject you can find the best
composition – and see what is
better left out. Personally, I prefer
to peer through my fingers at the
subject (see photograph) but some
people find this awkward.

BACKGROUNDS

If just painting a head and
shoulders it is probably best to
keep the background simple. If the
head is painted with sufficient
intensity and atmosphere it will be
enough. A neutral gray mid-tone
behind a head enhances its warm
coloring and if the background is
graded lighter on the darker side of
the head and darker on the lit side,
an illusion of space and depth is
soon created. This device has been
popular with portrait painters since
the Renaissance.

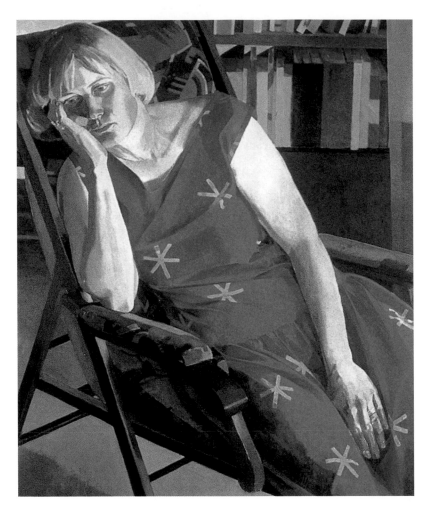

LEFT Ivy Smith, *Portrait of Julie* (oil on canvas), 36 x 30in.
This chair has suggested a diagonal composition. The twist of Julie's pose and the direction of her gaze cut across the diagonals created by the chair and her right arm.

OPPOSITE PAGE David Cuthbert, *Tomasin* (acrylic on paper), 30 x 22in.
This painting makes an interesting comparison with Juliet Wood's *Emily in cycling shorts* (page 28). Here, Tomasin also occupies half the picture space, her contour forming a steep curving diagonal, while the rest of the picture is given over to the room. In this case, though, the artist has simplified the elements of door, wall, floor, and furniture surrounding the sitter with an almost abstract expression of space.

LOCATION AND POSE

A half or full-length portrait offers more scope for opening up space around and behind the subject. It is safest to paint what is there rather than using invention, at least at first. Try your model out in various parts of the room before deciding. "Which room?" is also a good question. I can think of wonderful portraits painted in bathrooms, hallways, and backyard sheds. As for the pose itself, I always allow my subjects to find their own natural pose or way of sitting. Sometimes we try out a few different things, but if self-consciousness creeps in it is usually detrimental unless a theatrical effect is what you desire.

It is also important to put your sitter at ease, even if it is someone you know well. A relaxed pose is more attractive than a stiff, self-conscious one, and your sitter will not tire so quickly either. Actually, people relax by degrees and a pose in half an hour's time is not what it was to begin with. This is another good reason for doing a sketch or two before starting to paint, rather than making adjustments later.

COLOR AND LINE

Verticals and horizontals give stability, diagonals suggest movement. Furniture or paneling, a window frame perhaps, may provide

a choice and offer inspiration. Symmetry is best avoided, though this does not mean you have to avoid a directly forward-facing pose. The essential thing is to create the illusion of space, whether shallow or deep, and to entice the eye around and into the painting.

Try to be aware of light–dark relationships in your composition. For example, if your model is wearing a large dark hat this will frame the head and so a pale background could be used. But if she is blonde, a mid-toned background will emphasize her face while a very dark color might be overpowering. I should, at the risk of seeming to contradict myself,

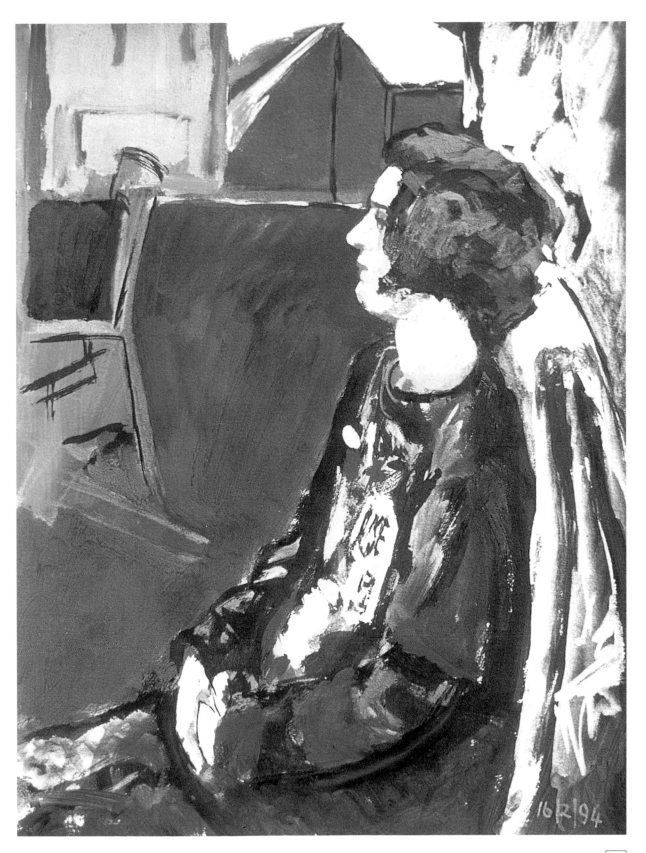

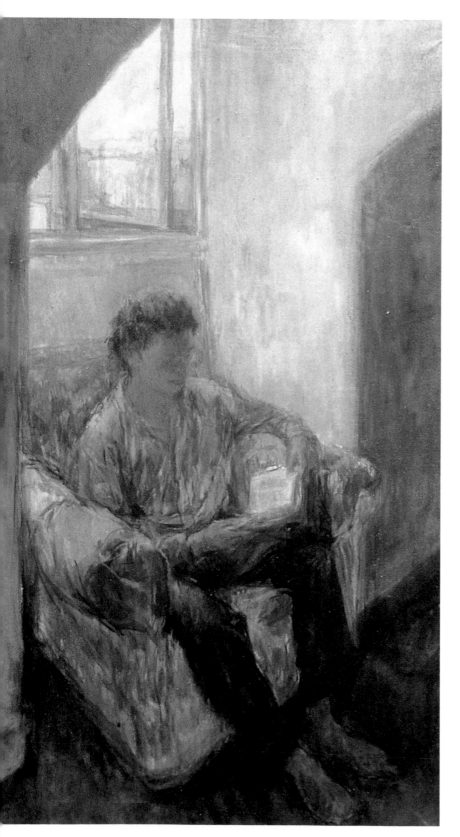

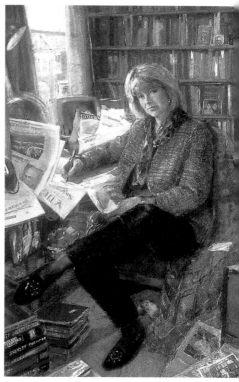

LEFT Helen Elwes, *Martin*
(oil on canvas), 16 x 12in.
The window alcove provided the inspiration for this composition. The figure is strongly contained, firstly by the alcove and secondly by the chair, and picture space is dramatically divided between light and dark. The sitter's pensive attitude and the delicate treatment of the lit areas contrast with the dark elbows of shadow on each side.

ABOVE Barry Atherton, *Julia Somerville*
(pastel and collage), 60 x 40in.
The angular pose of the subject is echoed all around in the chaos of books and papers. Newspapers were used as collage material and their headlines preserved in the final result.

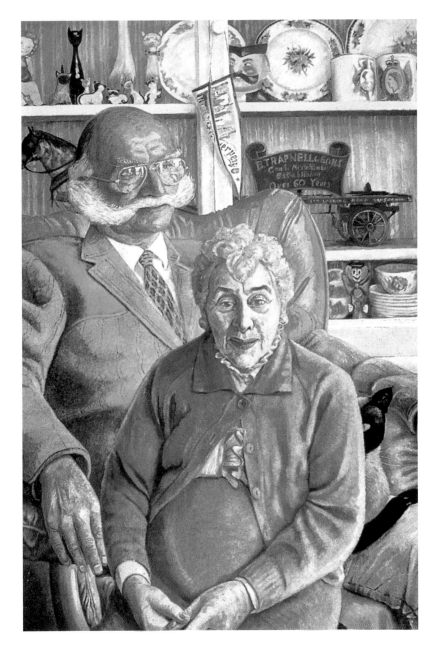

RIGHT Ros Cuthbert, *Ray and Moya Trapnell* (oil on canvas), 42 x 24in. This composition was inspired by a Stanley Spencer portrait of two sisters. Ray and Moya sit on separate seats, one in front of the other, giving a compressed sense of the space between them. The objects in the cabinet behind provide a narrative of the sitters' lives.

mention that black has been used in some superb portraits by great masters from Velasquez, Goya, and Rembrandt to Francis Bacon. Black emphasizes light, life and color in a face, but also gives a sense of fragility and impermanence.

Bright colors can be a problem in a portrait, as surrounding large areas of color do alter the way skin colors appear to the eye. There are reasons for this which are dealt with in Chapter 4. On the other hand, both color and pattern are essential ingredients in the portraits of artists such as Klimt, Matisse, Van Gogh, and Jawlenski.

TELLING A STORY

Some artists use objects to tell a story about their subject. I painted the couple above with their glass cabinet full of china cats and also a copy in miniature of the family coal wagon. Mr. Trapnell was a coal merchant and his wife used to breed cats. It seemed natural to include this in the painting as part of the couple's story. Such anecdotal details give enjoyment to the viewer as they provide a context for the portrait.

KURUMI

Acrylic on paper, 30 x 22in

D A V I D C U T H B E R T

For his portrait of Kurumi, David chooses a palette composed of
strongly contrasting colors and shades with which he integrates his subject
with her surroundings.

1

PALETTE	
	parchment (greenish cream)
	unbleached titanium (slightly pinky cream)
	raw sienna
	cadmium yellow
	cadmium red
	cadmium red deep
	quinacridone red
	burnt umber
	cerulean blue hue
	turquoise green

1 David covers the paper with a layer
of cerulean blue hue. He then
proceeds to draw in the composition
using cadmium red.

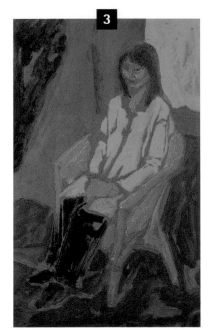

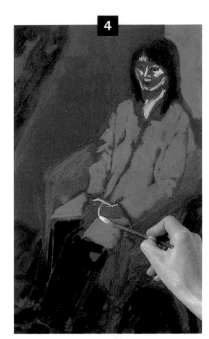

2 The next step is to block in the major color areas. He chooses unmixed colors, straight from the tube, intending to overpaint and adjust later. Here he is applying turquoise green.

3 At this stage all the main colors are blocked in and the composition is established, with colors in the surroundings relating to those on the figure. Colors used are raw sienna, burnt umber, and quinacridone red.

4 Next, David begins to explore the hands and face using unbleached titanium.

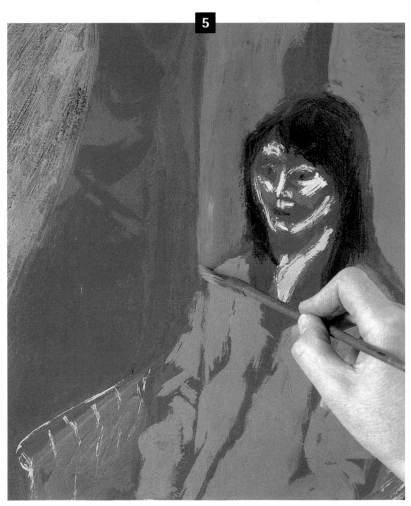

5 He then turns his attention to the orange drape. As this is so close to the face it will affect the skin tones; it will also enliven the adjacent blues. David uses a mixture of cadmium yellow and cadmium red.

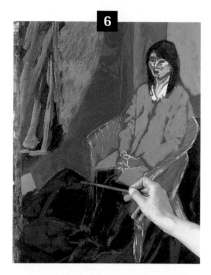

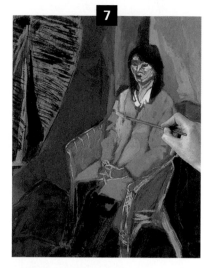

6 Having lightened and defined the top left corner with a thin layer of burnt umber and parchment, and added more of the flesh tint to the face, David now applies cadmium red deep to the drape on the floor.

7 The coat is given a lighter layer of blue mixed with turquoise green and parchment.

8 Kurumi's face receives a glaze of raw sienna.

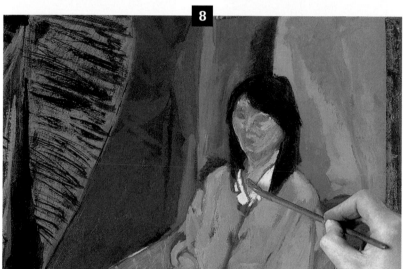

9 The likeness is then redrawn using thinned down cadmium red deep.

10 Highlights on the face and the earring are added with parchment.

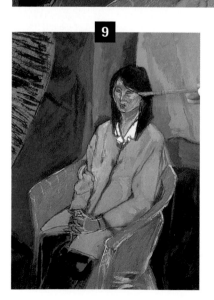

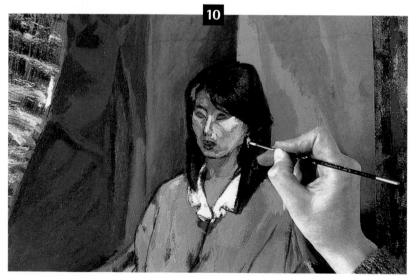

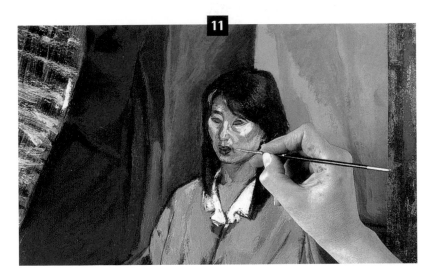

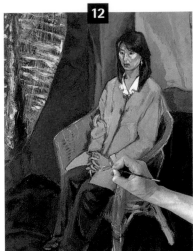

11 Shadows are touched in using raw sienna mixed with a tiny amount of burnt umber.

12 The chair is developed next, using raw sienna and parchment. The pants and shoes are painted using mixtures of burnt umber, cadmium red, and unbleached titanium. Here and there the original red underpainting is strengthened. Finally, David paints in the hands using unbleached titanium, raw sienna, and cadmium red.

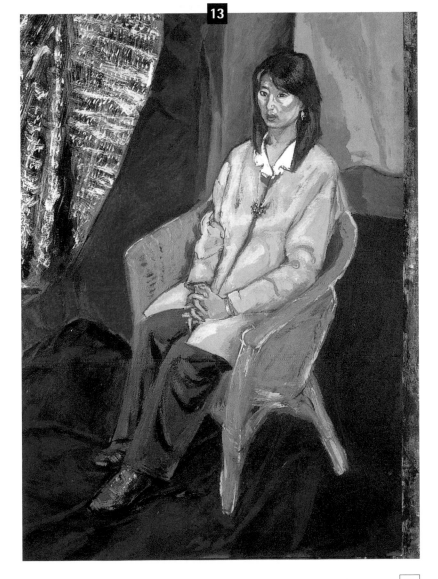

13 The finished painting. The colors worn by Kurumi as well as her hair and flesh colors are all repeated elsewhere in the composition. The strong reds and oranges are allowed to leak into the linework on the figure. Warm/cool and light/dark contrasts are beautifully balanced.

4

PAINTING

SKIN TONES

I AM OFTEN ASKED IN PORTRAIT CLASSES HOW TO PAINT SKIN. BEGINNERS TEND TO THINK THERE IS "A WAY TO DO IT" BUT THIS IS NOT REALLY SO. ALL COLORS ARE ALSO TONE, IN THE SENSE THAT THEY HAVE A TONAL VALUE. VIOLET, FOR EXAMPLE, IS DARK AND YELLOW IS PALE. THE IMPORTANT THING IS TO PRACTICE MIXING THE COLORS YOU SEE AS ACCURATELY AS POSSIBLE. LATER ON YOU MAY REALIZE THAT COLORS CAN BE MANIPULATED TO GIVE CERTAIN EFFECTS, BUT THE FIRST CONCERN SHOULD ALWAYS BE SIMPLY TO RECORD WHAT IS THERE AS FAITHFULLY AS POSSIBLE. A "WAY TO DO IT" REVEALS ITSELF SLOWLY. THIS IS SO MUCH BETTER THAN BEING PROVIDED WITH A CRUTCH WHICH MAY BE HARD TO DISCARD LATER.

There are very many different skin types, even in the same ethnic group. For example, a "white" person can be pale peachy pink, creamy bluish white, olive-skinned or even deep red. Asian and African skins are equally varied. Not only this, but light itself as we have seen can be "warm" or "cool" in color temperature, further complicating the choice of palette.

CHOOSING A PALETTE

Begin then with a simple palette setting, or choice of pigments. Why not begin in oils or acrylic with the palette of a great master. Rembrandt used only four, possibly five, pigments. They were black,

RIGHT Ros Cuthbert, *Master Sheng Yen* (oil on board), 16 x 12in.
Light from the yellow wall transforms the half tones. Pigments used for "Shih-Fu," a Chinese Ch'an Master, were titanium white, yellow ocher, cadmium red, cobalt blue, cerulean blue, cadmium yellow, lemon yellow, raw umber, and raw sienna.

OPPOSITE PAGE Jerry Hicks, *Drew McClung* (oil on canvas on board), 24 x 20in.

BELOW Jane Bond, *Jeremy* (oil on board), 24 x 30in.
Jane's palette is very large and she uses the same one for every picture. It consists of titanium white, ivory black, indigo, cobalt blue, cerulean, viridian, terre verte, oxide of chromium, alazarin crimson, cadmium red, cadmium yellow, lemon yellow, yellow ocher, Indian red, burnt sienna, and brown madder alazarin.

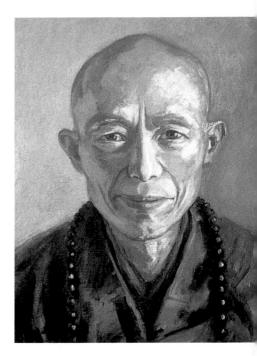

LEFT Jack Seymour, *Mr Yates, Caretaker*
(oil on canvas), 26 x 19in.
Jack's palette for this portrait was
Davy's gray, ultramarine, terre verte,
titanium white, yellow ocher, Mars
violet, rose madder, raw umber, and
ivory black. The artist worked on a
medium toned raw umber ground which
had been applied over a homemade,
oil-based primer.

FAR RIGHT Ros Cuthbert, *Tita*
(oil on canvas), 60 x 24in.
For Tita's skin I used a magenta
underpainting followed by mixes of
titanium white, Venetian red, cadmium
orange, raw umber, cerulean blue, and
cadmium red.

RIGHT Jane Percival, *Rosemary*
(oil on board), 17½ x 16in.
This study shows how the flesh tint was
laid on and the likeness obtained by
drawing with a darker shade which also
works as a half tone. Colors used were
white, yellow ocher, raw sienna, and
cadmium red.

white, yellow ocher, and light red (a
red-brown pigment), with the
possible addition of raw umber. A
"white" skin painted in north light
conditions can be reproduced with
just these few colors. So the first
thing is to become familiar with
this palette setting by painting
several portraits with it. This simple
palette and a cool, steady north
light will introduce you gently to
the subtleties of interpreting colors
and tone values in a human face.

Having first drawn in the
contours you will need to mix a
flesh tint and a half tone. To find
the former, look at the color next to
the highlight. It could be mixed
using a correct balance of white,
light red, and ocher. The half tone
will need to be scrutinized carefully.
It is the tone color between the
flesh tint and the deepest shadow
areas – in the nostril or ear perhaps
– and being darker and cooler than
the flesh tint will need added black
and possibly a little more yellow
ocher and light red. This shade may
need to be greenish compared with
the flesh tint and black works well
to produce this effect. Remember
to add only a very little at a time.
Darks such as nostrils and shadows
in ears may need warming up with a
little light red, and cheeks, if they
are pink, may need a touch of
cadmium scarlet or crimson
alizarin. Highlights, if you are
working in north light, will be
bluish. Lighten the flesh tint with
white to the required tonal value
and cool it with a tiny touch of
black, or, if you prefer, cerulean or
cobalt blue. A pale gray, though,
mixed with white and black, should

read as bluish if surrounded by warm flesh colors. (Rubens used pale yellow highlights which might also read as sufficiently cold against flesh tints to produce the correct effect.) In my experience, it is far better to mix your own flesh tint than to buy it ready mixed in a tube.

These days, many portrait artists use a brighter palette than those used by old masters such as Rembrandt, Hals, Romney, and Reynolds. Having tried this palette setting, you may begin to form ideas about your own color

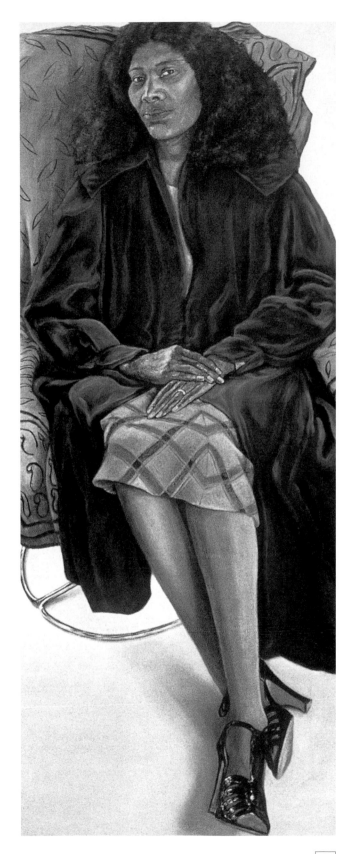

sensibilities. If painting a child, the palette might need to be capable of producing delicate, clean colors. Try cadmium orange and white as a flesh tint, or cadmium scarlet and lemon yellow (or cadmium yellow pale which is a more opaque pigment) with white, subdued with cobalt blue for the half tone. The colors should be mixed with the utmost care and tone values not over darkened, the blending done lovingly to produce the delicate movements from light to shade and to preserve the luminous quality of a child's flesh. (To learn more about obtaining the luminous quality of flesh using oils, turn to page 107.)

A face which has been outdoors in all weathers may be reddish or even purplish, requiring cadmium red or carmine, and possibly ultramarine in the flesh tint. A sun-bronzed skin will need an addition of raw sienna and/or cadmium scarlet or possibly a cooler red such as cadmium red deep, which can be further cooled for the half tones with cobalt blue. Remember that shadows are generally cooler in color than the flesh tint, and the highlight takes on the colors of the light source.

A "black" person may be anything from a warm coffee color to very dark, almost black. Look for the warmth in the flesh tint. Having mixed a brown with, say, raw sienna, Venetian red, and white, check that you do not need to warm it further, especially on the cheeks. Note the bluish sheen often present on very dark skins – a most exciting quality to paint. Lips are warmer than the overall flesh tint – add a touch of crimson – but do not overdo it unless your model is wearing lipstick.

ABOVE Robert Maxwell Wood, *Girl with locks* **(oil on canvas), 16 x 12in. Max always uses the same palette setting which he keeps permanently arranged on his palette. The pigments he used are cadmiums yellow, lemon, orange and red, Rowney rose, transparent violet, cerulean blue, ultramarine blue, viridian, cadmium green, and cremnitz white.**

RIGHT Ros Cuthbert, *Hedda* **(oil on canvas), 24 x 24in. I painted this two-year-old girl from photographs backed up with sketches. My palette setting was titanium white, yellow ocher, raw sienna, and raw umber, with touches of cadmium red, rose madder, and cobalt blue.**

OPPOSITE PAGE Ivy Smith, *Lunchtime on Reynolds Ward* **– detail of Celestine (oil on canvas), 60 x 120in. The palette setting for Celestine was yellow ocher and rose madder. She was painted from black and white drawings.**

When you sit down to paint a portrait you will probably feel excited and nervous. It is a bit like standing on the edge of a diving board. I am sometimes, even now, assailed by the sensation of near terror when I begin a commissioned portrait. Looking at my subject I wonder how I ever got myself into this situation. The complexities and subtleties of decision after decision seem to stretch ahead endlessly. But this sensation rapidly disappears when I begin work, and twenty minutes later I am secretly smiling at myself. Keep your palette simple and ordered, with white in the middle, cool colors on one side and warm colors on the other. With practice you will gain

both confidence and control. It is important to have a method to help you stay on course, but also to realize eventually that the method must be flexible to allow for particular conditions. Further advice on methods are found in the chapters on working with specific media (page 88–111).

LIGHT AND COLOR

If you are painting in sunlight or warm artificial light you will need to adjust your palette. Some artificial light is cold – my own studio is fitted with "north light" fluorescents – but domestic lighting is generally warm. Thus the flesh tints will appear warmer and you may feel the need of a dab of lemon yellow or Naples yellow. Beware of overdoing it – too much yellow can result in a case of jaundice!

I have already mentioned the effect of reflected light. It can affect both directly lit and shadowy sides of your sitter's face, though on the lit side it is not usually visible as such. However, if light is reflecting on to the skin from a brightly colored surface it will carry that color with it. This has a transforming effect, as described in Chapter 2. We have all, as children, held a buttercup beneath a friend's chin to see whether they "liked butter." Invariably they did. If the reflected light is red it will dramatically warm the normally

cool tones in shadowy areas. Thus a red dress or shirt can have a profound influence on the half tones. Blue reflected light registers as mauvish on "white" skin, an effect often present beside a swimming pool on a sunny day. Such things are delightful but might not be desirable in certain types of commissioned portrait as they do distort the natural flesh colors.

INTERACTIVE COLORS

The last point about painting skin tones is very important and is the reason why I like to say there is no such color as flesh color. Our eyes are designed to seek a balance of complimentary colors. This is not the place for a lesson on complimentary color harmonies, which can be looked up elsewhere. But if you stare fixedly at a large bright patch of red and then move your gaze to a white surface, what you see is a green after-image. In subtle ways, this dynamic interaction is going on all the time without our being aware of it. But as your "painter's eye" develops, you will begin to notice that if there is a large area of, say, red behind your sitter or if he/she is wearing red or bright pink, the skin colors may appear greenish. Similarly, a surfeit of bright violet will give the skin a yellowish appearance, while yellow makes pale skins look rather sallow or gray. This can be used to advantage, for instance, blues, greens, and cool grays enhance the warm appearance of flesh. In short, no color exists by itself but is influenced by what is adjacent to it. It is this interactive quality which is a source of such endless fascination for artists.

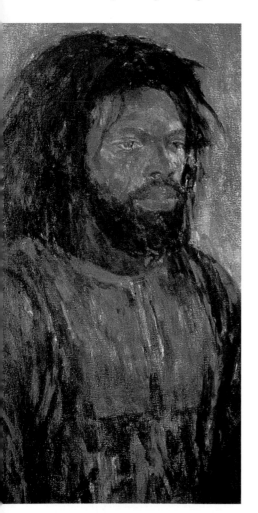

LEFT Helen Elwes, Barry – detail (oil on canvas), 30 x 20in.
Helen's palette setting is burnt umber, raw umber, burnt sienna, raw sienna, yellow ocher, cobalt blue, ultramarine, alizarin crimson, cadmium red, cadmium yellow pale, lemon yellow, terre verte, viridian, and flake white. She never uses black, preferring to mix her own darks.

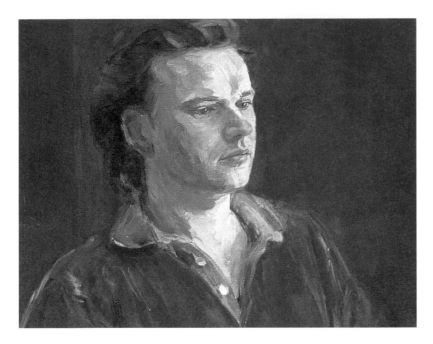

LEFT Juliet Wood, *Leo in Red*
(oil on canvas), 19 x 23in.
With its daring use of red, this portrait
shows how color reflects back into the
half tones. Notice the use, too, of green
in the half tones and in the shadows on
the subject's shirt.

BELOW David Cuthbert, *The Satin Dress*
– detail (acrylic on paper), 30 x 22in.
This painting makes an interesting
comparison with Juliet Wood's *Leo in
Red* (above). The handling is much freer
but, here again, green has been used,
this time as a highlight. The flesh tints
have all but dissolved into red reflected
color.

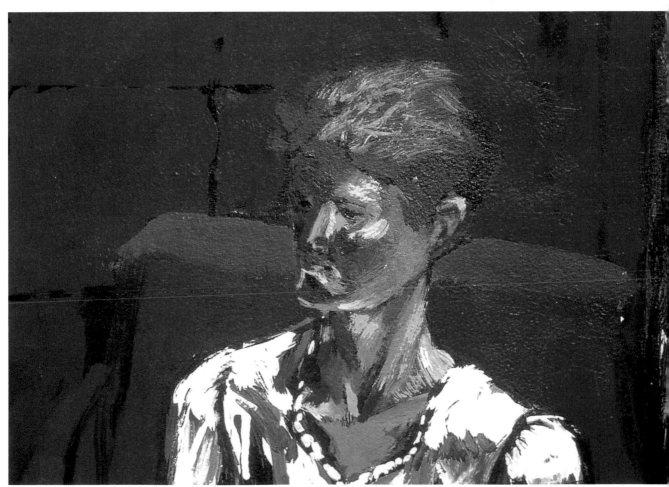

JAZ

Oil on board, 12 x 9in

R O S C U T H B E R T

It is interesting to see how blue and green are used in this otherwise
warm-toned complexion.

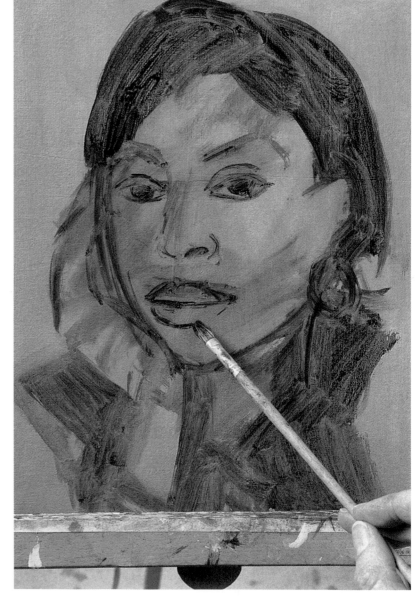

1 The imprimatura – a word used to
describe the tinting of a white ground
prior to painting – is in two layers,
cadmium scarlet followed by a
mixture of white and raw umber. I
begin the underpainting with
magenta thinned with turpentine,
blocking in the head and hand boldly
to establish the composition.

2 Adding monestial turquoise to the
magenta, I block in dark areas and
establish a likeness. The paint is kept
thin so that I can move it around easily

titanium white

monestial turquoise

magenta

lemon yellow

cadmium orange

Indian red

cadmium red

Mars violet

cobalt green

cerulean blue

ivory black

sepia

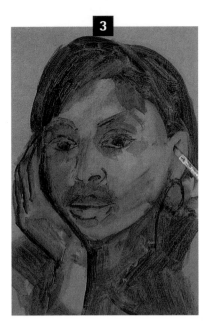

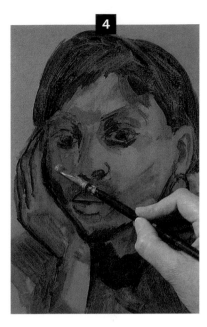

3 With a mixture of white, cobalt green, and cadmium orange, I block in the half tones next.

4 Then I mix a flesh tint using cadmium orange, cobalt green, Indian red, and white.

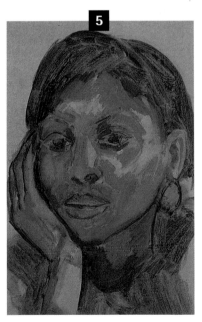

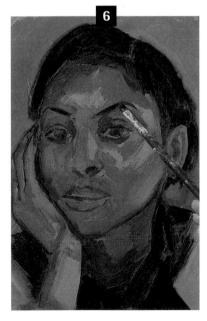

5 At this stage the flesh tint is blocked in but the underpainting is still visible.

6 I block in the background with a mixture of cadmium orange and cadmium red, and strengthen the hair, eyes, and eyebrows with sepia.

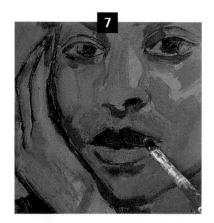

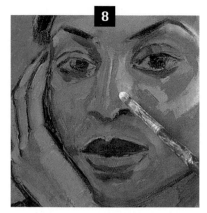

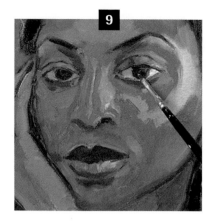

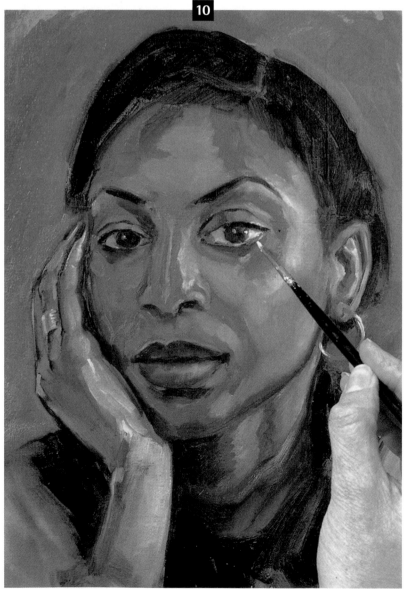

7 The upper lip is darkened with a mixture of Mars violet and sepia.

8 Highlights are added next using cobalt green and white, with the addition of cerulean blue on the cheek bone and nose, and upper and lower lip.

9 The eyes are developed using Indian red on the iris and cerulean blue and white for the whites.

10 Highlights are added with titanium white warmed up with a little lemon yellow.

11 Using ivory black and sepia, the fringe is pulled forward over the forehead and the hair is completed.

12 Finally, a few textural details are added to the jumper with sepia, black, and white, and the picture is complete.

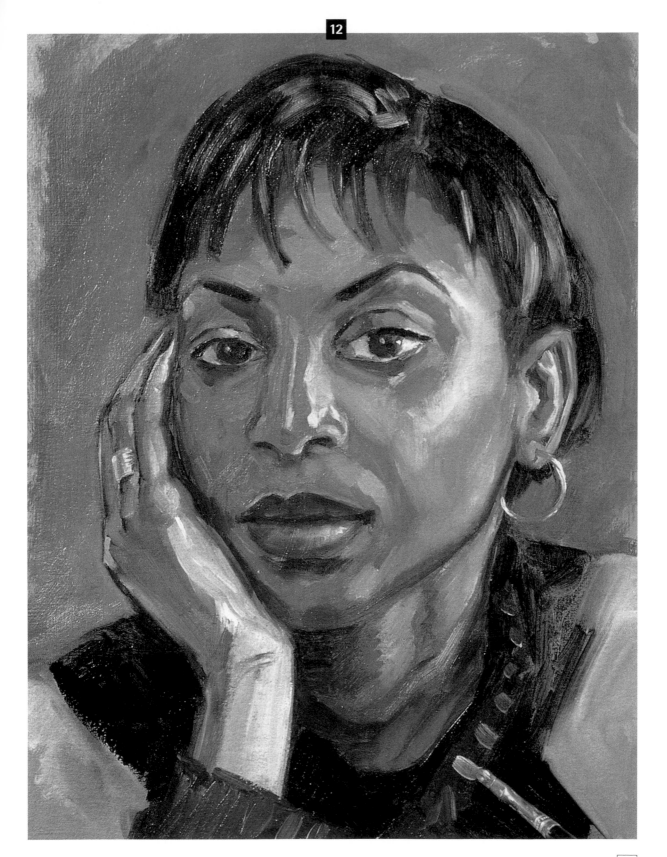

5

EYES AND MOUTHS

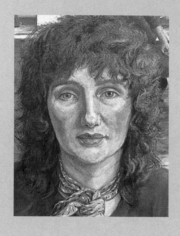

I N CHAPTER 1, WE HAVE SEEN THAT THE HEAD AND FACE ARE SUBJECT TO THE LAWS OF PERSPECTIVE AND THAT FORMS ARE FORESHORTENED AS THEY DISAPPEAR AROUND THE CURVE OF THE HEAD.

BY TAKING EACH FEATURE SEPARATELY WE CAN OBSERVE THE SPECIFIC PROBLEMS OF EACH AND SEE HOW WE MIGHT DRAW AND PAINT THEM. ONCE AGAIN, I SHALL SUGGEST CLOSE SCRUTINY OF THE SUBJECT, BACKED UP BY AN UNDERSTANDING OF THE FORMS AND THEIR SPATIAL RELATIONSHIPS. THE IMPORTANT THING THOUGH IS NOT JUST THE SHAPE OF A FEATURE, BUT ITS INTEGRATION INTO THE WHOLE HEAD.

THE EYES

The eye is close to being a perfect sphere. Most of it is hidden inside the eye socket with only a small section visible – perhaps less than an eighth of the whole surface area. The iris bulges forward from the white of the eye and is transparent. The eyelids are formed from a slit in the skin and the thickness of the epidermis is visible on the lower lid between eyeball and eyelashes. The curves of upper and lower lid do not exactly mirror one another; usually the lower lid is a flatter curve. The upper lid normally rests over the top part of the iris, which is detectable beneath it as the eyelid molds itself around it. If the eye moves from left to right this bulge changes the contour of the upper lid. The upper lid also has a crease above it formed between eye socket and eyeball. This crease

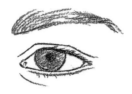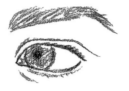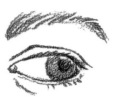

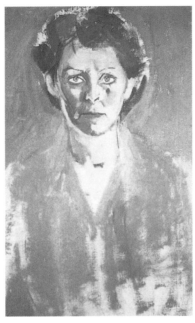

ABOVE Three drawings of the same eye looking in different directions.

LEFT Jane Percival, *Tina* (oil on canvas), 17½ x 16in.
Note the asymmetry of both eyes and eyebrows in this portrait. The woman is staring, and more white is visible below the iris than usual.

BELOW Stina Harris, *Heather Parkinson* – detail (oil on fabric on board), 36 x 72in.
It is often not until we paint a person that we notice that one eye is larger than the other, as is the case here.

OPPOSITE PAGE Ros Cuthbert, *Judith* – detail (oil on canvas), 42 x 33in.
Here, Judith's full lips are separated by the darker line of her mouth.

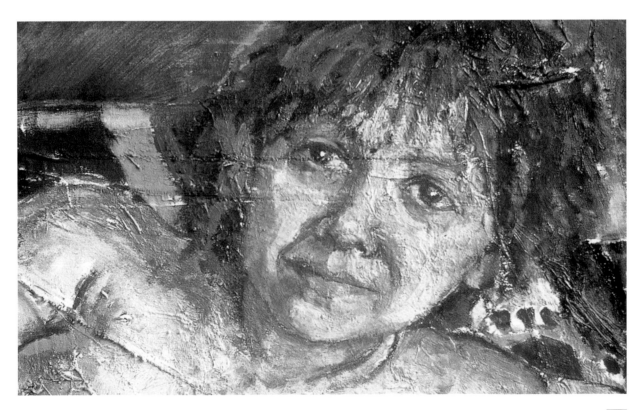

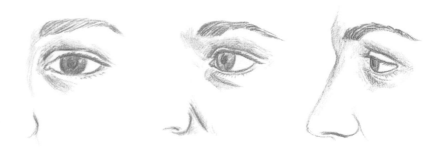

does not run parallel to the edge of
the upper lid but curves more
deeply, arching away from the eye
toward its center. In a young person
this curve is pure, but as the skin
loosens with age it alters and can
fold down over the upper lid. Study
the pure curves of a child's eyelids
and see how they relate. The
diagrams below will help. Ask your
model to look up, look down, and
look first right and then left so you
can draw the differences. Then do
the same working from an adult.

In the three-quarter view, the
curves of the eyelids appear
compressed, while in the profile
view the difficulty is to suggest that
the eye is not merely a flat triangle
but that its forms are moving
steeply away from you. Look for
every nuance of a curve of the lids,
and notice too that the eye itself is
set back behind the eyelids by the
thickness of the epidermis. Also, as
the iris is circular, in the three-
quarter and profile views it
becomes elliptical.

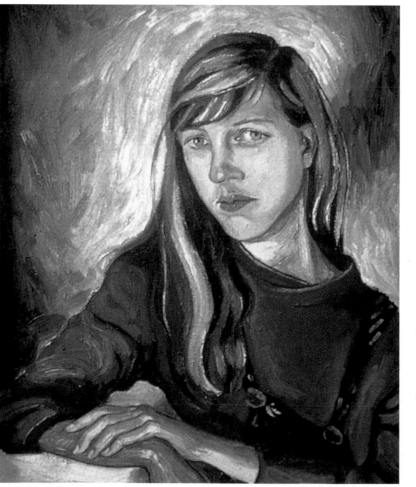

Points to remember when painting
an eye. It is easy to overstress the
subtle lines of an eye, so don't
make everything too heavy at first.
Look for the warmth in crease lines
and the pink in the inner corner –
the tear ducts. Some artists
successfully exaggerate the redness
of the tear duct to give heightened
contrast and to suggest life and
warmth. Whites of eyes are not as
white as their name. In a child they
might be pale blue, in an older
person pink-tinged. Most
importantly, notice the play of light
on the eye. Light crossing the eye
from the side will enter the iris
illuminating its opposite side. The
light and shade in an iris is the
other way around from the "white,"
rather as it is inside and outside of
a pitcher. Thus the highlight will
appear over the darker side of the
iris, on the side nearest the light
source. If you get this right, the eye

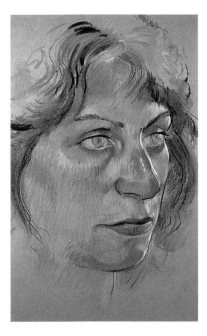

FAR LEFT Robert Maxwell Wood, *Head of Nicky* (charcoal and pastel), 21½ x 15in. Another three-quarter view. Note the steeper perspective on the far iris and pupil.

LEFT Robert Maxwell Wood, *Girl's profile* (black chalk), 15 x 12in. Here we have even less than a true profile. Note how, with a few marks, Max has linked the eye to the cheek, nose, and eye socket.

BELOW Ivy Smith, *Portrait of Sir Richard and Sir David Attenborough* – detail (oil on canvas), 60 x 49in. In this profile we look slightly down at the sitter. The lower eyelid thus appears to curve steeply while the upper is almost a straight line. The line of the eye socket is detectable in the fleshy forms around the eye.

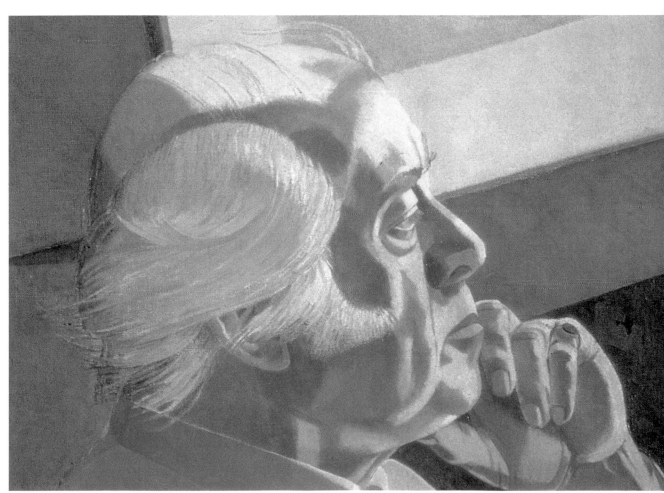

will appear transparent and alive. Observe too, that the iris has a ring of darker color around its circumference. The pupil is dark like the entrance to a cave, which is what it is in miniature. If black seems too "hard," try lightening it to a blue-black or even a warm, slightly reddish black. Eyelashes should be painted with delicacy so that they don't appear false. It may be better, depending on your style, to avoid depicting individual lashes. Study the work of the professionals to see how they cope with such details.

The left eye does not always exactly mirror the right. It might vary in size, shape or angle – or all three! Also study the color and texture of the skin around the eyes, which needs to be properly seated in its socket and related to brow, cheek, and nose to appear convincing.

Eyebrows too are important in the search for a likeness – more about this in Chapter 8.

THE MOUTH

The epidermis around the mouth is quite thick and woven with muscles giving it mobility and expression. A ring of muscle around the mouth enables us to purse our lips or pout, and radiating muscles help us smile, laugh, grimace, and so on. A full-lipped person is said to be generous while thin lips suggest meanness or cruelty. This is not necessarily the case, but it does show how important the lips are to us in reading someone's character and intentions. I think lips have more expressive power even than the eyes, certainly for the play of subtle and momentary emotions. Perhaps this explains why they are so extraordinarily difficult to paint.

So let's look at their structure. To begin with, they are not on a flat surface but follow the curve of teeth and jaws. This is the reason for the steep recession of the mouth in a three-quarter view. In the profile view the depth of that curve allows us to see the lips sideways on – if there were no curve and the lips rested on a flat surface we would not see them at all in a profile view.

The lips themselves are narrow at the corners and broaden out in the center as they curve forward from the mouth opening. The lower lip usually bulges slightly and the top lip forms the "cupid's bow" shape as it rises from each corner toward the center where it dips a little to accommodate the small groove joining it from the base of the nose. In the middle, the upper lip swells

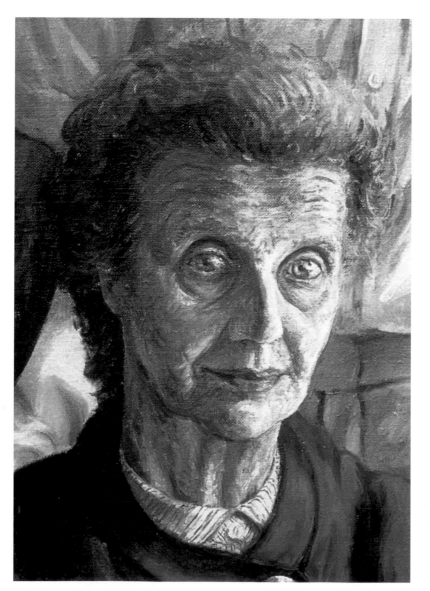

LEFT Ros Cuthbert, *Portrait of Group Captain Cheshire and Lady Ryder* – detail (oil on canvas), 39 x 27in.
In this portrait, the light is clearly visible entering from the side and shining on the side of the iris furthest from the light source.

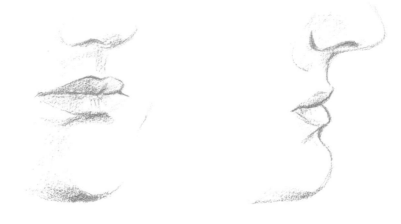

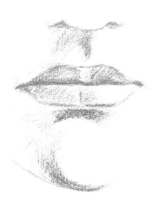

TOP Three views of the same mouth seen (left) in full face, (center) in three-quarter view and (right) in profile.

ABOVE David Cuthbert, *Louise* (acrylic on paper), 30 x 22in. This little mouth is simply drawn and done almost entirely with transparent layers of paint. The pout is accented by a deep shadow between the lower lip and chin.

RIGHT Robert Maxwell Wood, *Man from Green Ore* (oil on canvas), 16 x 12in. As with the portrait of Bruce (overleaf), we are looking slightly down at the subject and the shape of his mouth follows the curve of his jaws and teeth. In this case the lips are so thin that only the center line is visible.

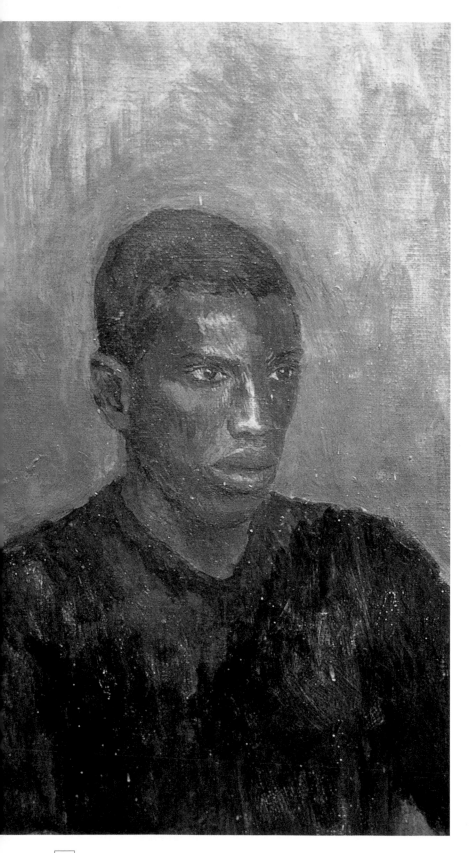

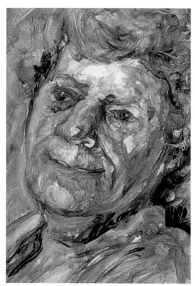

LEFT Helen Elwes, *Bruce* – detail
(oil on canvas), 16 x 12in.
Bruce's lower lip is lit by a broad
highlight while his upper lip is more in
shadow, except around the top edge
where highlighting is visible.

ABOVE Ros Cuthbert, *Study of the artist's*
mother (oil on board), 10 x 7in.
The mouth is curving but this time it is
evidently a smile, as the crease lines
each side are drawn up like drapes.
This study was done in less than an
hour. As with the *Man from Green Ore*
(page 57), the mouth line is not a
continuous dark line but is modulated
to describe the changing effects of light
and shade along its length.

forward slightly. The lips do not
come together in a straight line –
again the "cupid's bow" is visible in
the give and take between them.
Even in very straight, thin lips these
curves are almost always detectable
to some degree. When drawing lips,
first look for the position of this
center line (which has more tonal
weight than the others); and when
painting, make nothing too hard or
the lips will look stuck on.

As with the eyes, it is important
to relate the lips to the surrounding
forms. In the profile view you can

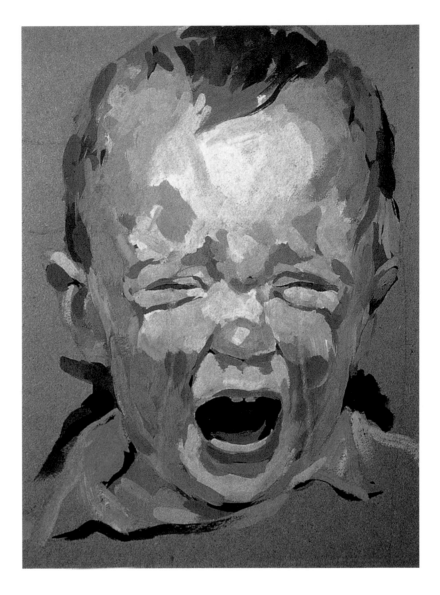

see that they spring forward from chin and nose. Either side of the mouth is a crease line curving down and around from the nostrils. In children, this will only be visible as a change in direction of the volumes of the cheek and mouth area, but in an elderly person you will notice a deep crease. All around the mouth the volumes change direction and are lit or shaded accordingly. The trickiest part to paint is possibly the corners which in a child disappear flawlessly into the surrounding

flesh with the merest indication of a slightly angled shadow. With age, this shadow can deepen and even form a small crease which nevertheless should be painted with great delicacy so as not to spoil the likeness or give too sombre an expression. Also with age, lips often become thinner and of course flesh sags. The aging process produces lovely qualities in a face, which are often more fun – and less tricky – to paint than a flawless complexion. In any case, we are surrounded by examples.

Be observant even when not painting – and draw whenever you can.

If painting an open mouth, do not make the teeth too white. They are normally a dark ivory or sometimes even quite gray or yellowish. (I can think of a portrait by Ingres of a young woman with quite dark, rotten teeth.) Also, notice the effects of shadow on teeth: very important if they are to appear realistically behind the lips. Unshaded teeth can produce the stereotypical piano-key effect!

6

NOSES AND EARS

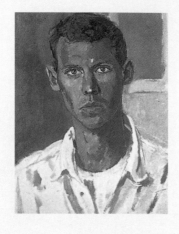

WHILE EYES AND LIPS REMAIN CLOSE TO THE CURVED SURFACE OF THE FACE, NOSES AND EARS PROJECT OUT FROM IT. A NOSE CAN CAST A SHADOW LIKE THE GNOMON ON A SUNDIAL AND EARS TOO CAN CAST SHADOWS ON THE FACE IF LIT FROM BEHIND. IN SOFT LIGHT A NOSE CAN BE DIFFICULT TO SEE AS A PROJECTING SHAPE, ESPECIALLY FROM THE FRONT. IN THIS CHAPTER WE WILL LOOK AT THESE PROJECTING FORMS, SEE HOW LIGHT AND SHADE ENABLE US TO MODEL THEM, AND HOW THEY RELATE TO THE HEAD AS A WHOLE.

LEFT Three drawings of the same nose seen from different angles – (left) front view, (center) three-quarter view and (right) in profile.

BELOW Helen Elwes, *Self portrait* – detail (oil on canvas), 24 x 18in. In this three-quarter view, the near side of the nose is barely darker than the cheek. Light on the nostrils and along the edge of the nose is perfectly judged. Without these touches the nose would remain flat. This painting was inspired by the famous Dürer self portrait.

THE NOSE

The nose occupies a most important position, linking the other features as well as all the fleshy areas around them. From the side it is roughly triangular, two elongated triangles, leaning together to form its length. At its base is another much smaller triangle. From the front too, its form is triangular, wider at the nostrils than at the bridge. The angles of these triangles must be judged correctly if the likeness is to be caught. In fact by now you will have realized that the likeness depends on everything coming together in just the right way.

The front view presents problems because there are no contour lines to show that it projects forward. This illusion has to be achieved by handling the light and shade correctly. Highlights along the nose and at its tip are most helpful here. The nostrils should not be painted too round or too dark. When viewed from the front they are seen at their narrowest and the shadow

OPPOSITE PAGE Jane Percival, *Caspar* (oil on canvas), 18 x 20in. This is not quite a full face view but the ears are not symmetrical, one being roundish and the other flatter. Noting these deviations from symmetry are a crucial part of capturing the likeness.

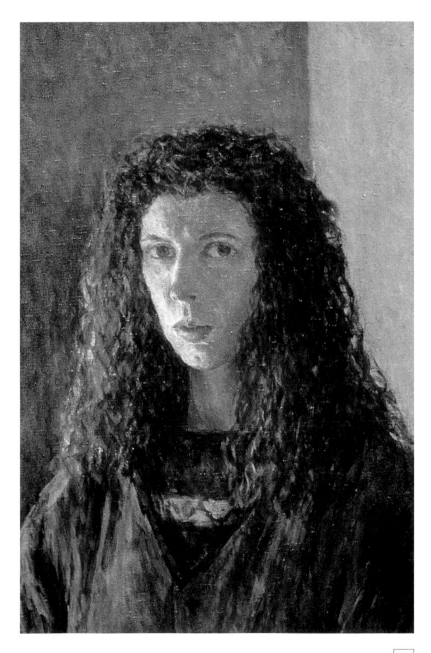

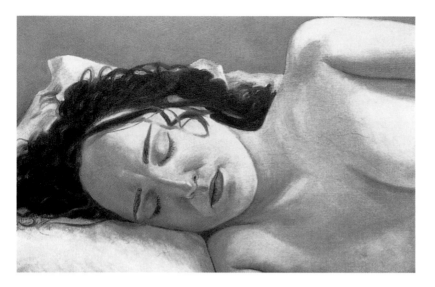

LEFT Ros Cuthbert, *Last of the Snow* – detail (oil on board), 36 x 60in.
Because of reflected light from the pillow lighting the half tones, the girl's nose has a central panel of shadow running along its length. The highlight next to this shadow shows that the nose projects forward, and is very important since the modeling is otherwise very light.

BELOW Brian Luker, *Geoff* (pencil and watercolor), 16 x 12in.
The watercolor washes are kept simple and the shading and contouring done with pencil. Note the subtle but necessary light on the bridge of the nose.

gradually darkens from below. Do not paint them as an ungradated dark shape unless that is truly the case. The fleshy areas containing the nostrils are also difficult: there is no substitute for close observation. Do not overestimate the size of the nostrils or their distance apart. Note any shadows at the base and any difference in coloration of the flesh tint.

In a front view, be sure to observe correctly the length of the nose relative to the height of the forehead and length of the chin. Check it in relation to the shape of the jaw – this is very important. Finding a likeness is a highly analytical procedure – nothing should be taken for granted. I often find at first that I am having to work hard at "building" the underlying geometry of a face, but at a certain point something clicks into place and I begin to recognize my sitter's likeness in the marks I have made. When this happens I rapidly get into the flow of developing the surface and resolving light and shade, color and expression. When I have forgotten about myself, things are going well.

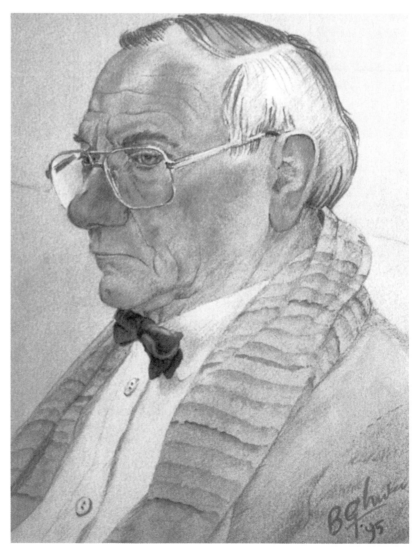

RIGHT Jack Seymour, *Una Troubridge and Radcliffe Hall* (oil on board), 10 x 8in.
These two profiles, make an interesting comparison of the different angles of the nostril and the base of the nose.

BELOW TOP Robert Maxwell Wood, *Woman with pony tail* (black chalk), 16½ x 12in.
In this fast drawing Max has linked the nose and upper lip in a single line.

BELOW BOTTOM Robert Maxwell Wood, *Study for Compassion* (charcoal and pastel), 16 x 12in.
A more fully modeled study in which the smallest specks of light are sufficient to describe a contour.

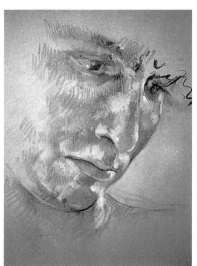

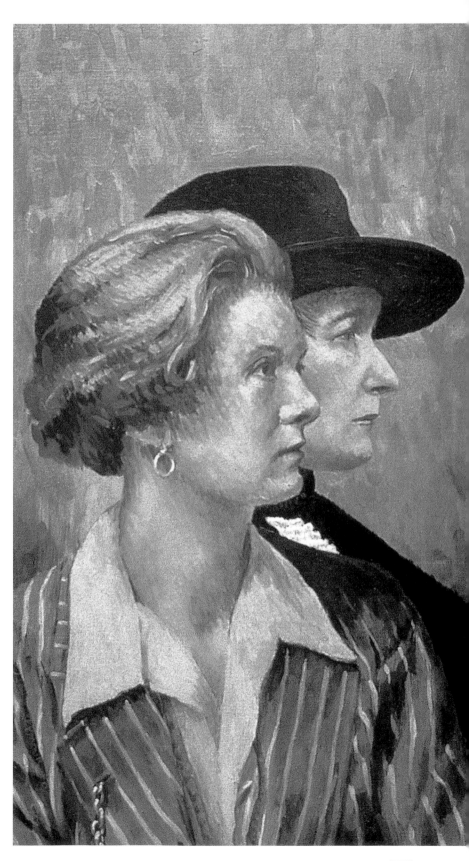

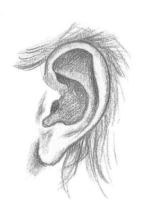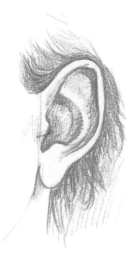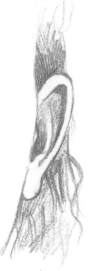

LEFT **Three drawings of an ear seen from different angles – (left) from the side (profile view), (center) three-quarter view and (right) from the front.**

BELOW **Ivy Smith, *Portrait of Rowan Entwhistle* (oil on canvas), 24 x 20in. Rowan's gaze is downward and her chin has dropped a little, consequently the ear is placed fairly high. The ear is fully modeled but painted more broadly and simply than the other features.**

THE EARS

These are set at some distance from the other features, on the side of the head. This distance is often under or over-estimated. Careful measurement from ear to outer corner of eye should clear up any problems. The ear springs from the head partly over the jawbone's joint with the skull (check this by feeling your own ear and jaw) and is most fully visible in a profile view. Its size and shape can vary greatly but is most usefully compared with the nose on a horizontal axis as discussed in Chapter 1.

The ear is a beautiful organ, an unevenly spiraling form of flesh and cartilage designed to channel sound deep into the brain; but unless we are painting a profile view we do not fully see it. Ears can be as lovely as shells or as grotesque as cauliflowers. Interestingly, both these similes contain the idea of a spiral. From behind we can see how the ear grows out of the skull on a broadening conical base of cartilage and from the front we see it dramatically foreshortened in most cases. Ears are usually pinker in color than the face.

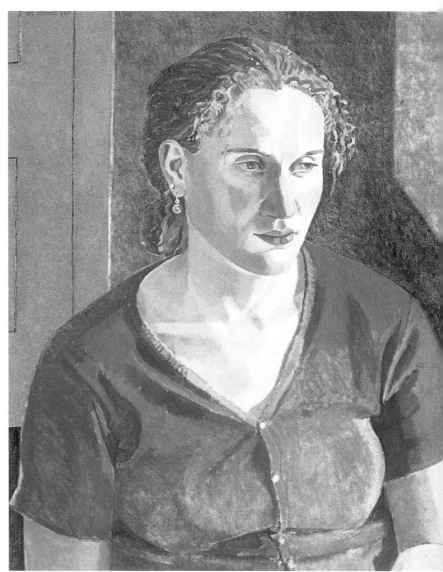

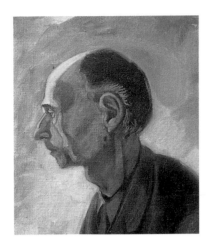

ABOVE Ros Cuthbert, *Study of Cecil Collins* (oil on canvas), 12 x 10in.
In a profile view the ear, if visible, becomes very important, occupying center stage.

It is useful to make a special study of drawing ears before you try to paint them, as they are quite complicated. Ask a friend to sit while you draw his or her ear from the side, then from the front and back, and also from above and below. In this way you will gain a three-dimensional understanding of the forms and an appreciation of how dramatically they change depending on your viewpoint. Do contour drawings and tonal drawings before working in colors. A child's ear differs from an adult's in shape, texture, and color. Earlobes can be long, short or non-existent.

**RIGHT Jane Percival, *Honey*
(oil on canvas), 20 x 18in.**
Once again, the subject is very slightly turned away from the viewer, this time looking over the artist's shoulder into the distance. The ears are small and not much of them is visible. Light first catches their top edges, each described by a single paint stroke. It is important to get such touches correctly placed – notice, for instance, that the top of Honey's right ear is a steeper line than that of the left.

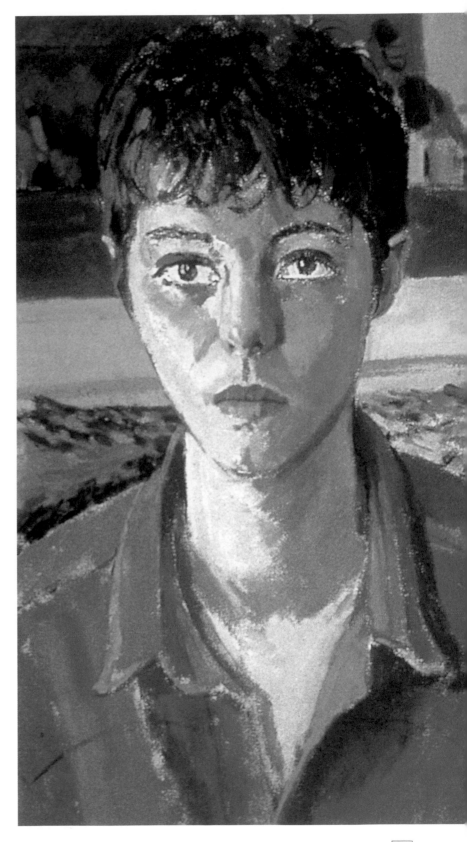

7

PAINTING HANDS

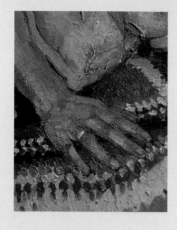

HANDS CAN CAUSE GREAT ANGUISH TO A STUDENT OF PORTRAITURE — ALSO, ON OCCASIONS, TO A PROFESSIONAL. THEY ARE CAPABLE OF SO MUCH MOVEMENT AND CAN ASSUME SUCH A VARIETY OF SHAPES, THAT IT IS A MIRACLE WE CAN RECOGNIZE THEM AT ALL FROM SOME ANGLES, LET ALONE DRAW THEM. AND YET WE MUST ATTEMPT TO, FOR HANDS CAN BE SO ELOQUENT IN A PORTRAIT, GIVING INSIGHT INTO THE SITTER'S CHARACTER AND PROVIDING THE PAINTER WITH ENDLESS POSSIBILITIES FOR EXPRESSIVE POWER. HERE AGAIN, A LITTLE UNDERSTANDING GOES A LONG WAY TOWARD SUCCESSFUL REPRESENTATION. IN THIS CHAPTER WE WILL LOOK AT THE STRUCTURE AND PROPORTIONS OF A HAND AS WELL AS THAT THORNY AREA, THE EFFECTS OF FORESHORTENING ON THE FINGERS.

First of all, let us look at the shape and proportions of a hand. It is broader and flatter than the wrist from which it springs. The palm is squarish, the thumb connecting low down toward the wrist. The fingers are jointed by three rows of knuckles, the first row being along the top of the palm. Each row of knuckles is shorter than the last, and the fingers also taper to focus the sense of touch. I particularly love the geometry of the hand which seems so perfectly designed. I love the way the length of the back of the hand equals the length of the

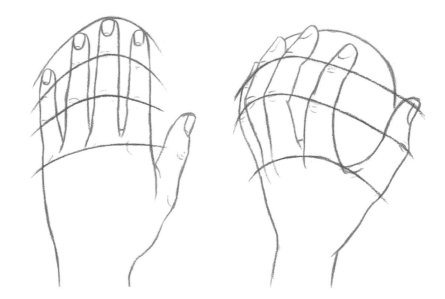

TOP LEFT Drawing showing the steepening curves of rows of knuckles.

TOP RIGHT Here, the fingers are no longer flat but curled around a ball. In this position the thumb knuckles relate more clearly.

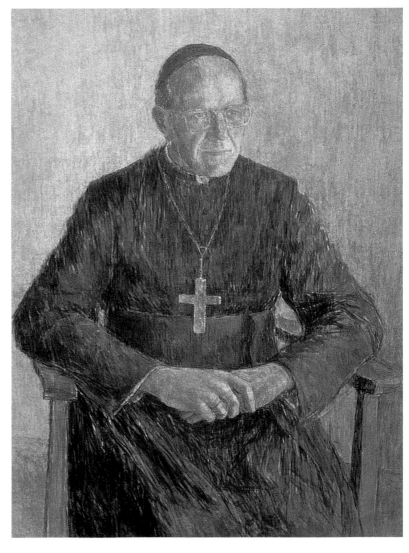

RIGHT Helen Elwes, *The Reverend Derek Warlock – Archbishop of Liverpool (England)* (oil on gesso), 22 x 18in. Understated shading gives the sitter's hands an ethereal mood.

OPPOSITE PAGE Stina Harris, *Heather Parkinson* – detail (oil on fabric on board), 36 x 72in.
This hand is painted using a flat hog brush. Brush marks are not blended but left to give a painterly texture.

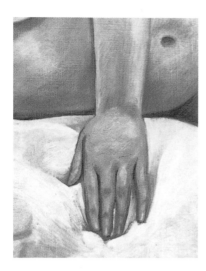

ABOVE **Ros Cuthbert**, *Last of the Snow* –
detail (oil on board), 36 x 60in.
Knuckles, and the soft shine on
fingernails, are indicated very simply so
as not to detract from the purity of line.

RIGHT **Linda Atherton**, *Moving Pictures*
(oil on canvas), 82 x 41in.
Hands in steep perspective can be
difficult to paint. In this picture Linda's
model appears to be pointing at her,
although he is looking down. The lower
part of his arm and his index finger are
in very steep perspective. Note the
deep shadows on the index finger and
thumb, and the use of the cuff to
suggest the volume of the arm.

first two finger-bones, and the
length of the first finger-bone equals
the sum of the remaining two, a
beautiful proportional relationship.
There is something wonderfully,
secretly inevitable about it. The way
in which the knuckles relate in rows
of deepening curves (see diagram)
is also exquisite. The thumb, too, is
a part of this pattern, which
becomes evident when holding an
object such as a cup or a ball. Draw
hands to become familiar with their
complexities. Draw and paint them
so that essentials of light, shade,
structure and character are
uppermost.

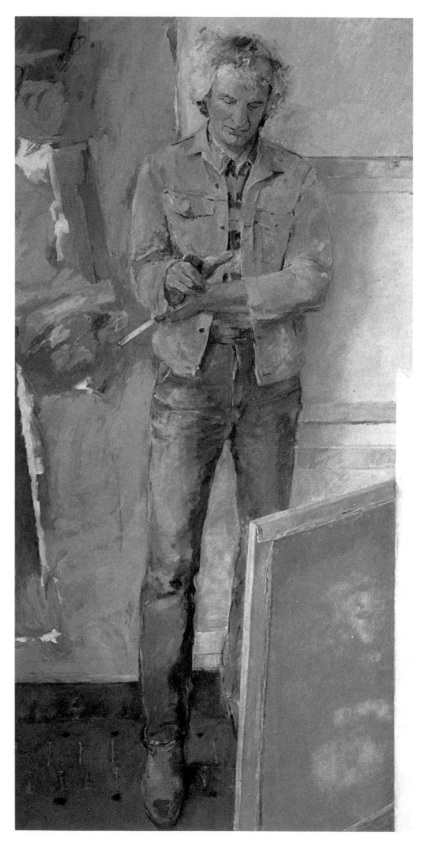

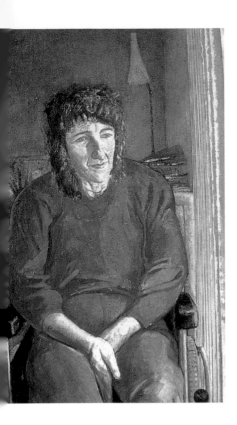

LEFT Ros Cuthbert, *Pat* – detail
(oil on canvas), 60 x 48in.
Pat, a multiple sclerosis sufferer, would
sometimes put her hands between her
legs to limit their involuntary jerking.
For this portrait, sand has been mixed
with the paint.

BELOW David Cuthbert, *Portrait of
Denise* (acrylic on paper), 30 x 22in.
In this vibrant portrait, linework has
been kept very separate from
modeling. The head rests heavily on the
left hand, the back of which is one of
the darkest areas in the picture.

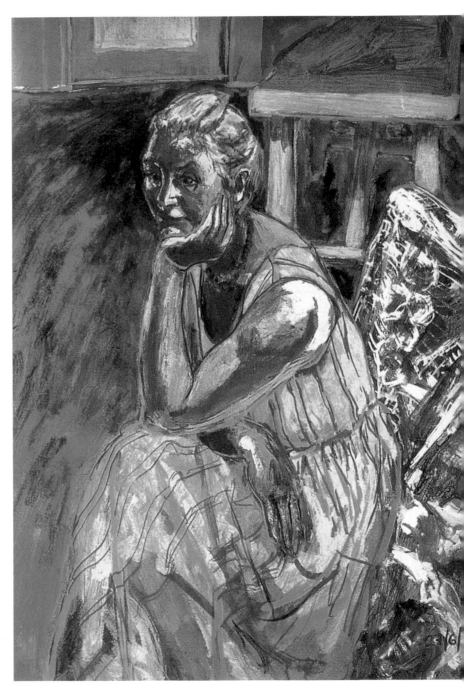

DETAILS OF HANDS

Fingernails are roughly oval and
curve both around the finger and
(much more subtly) along its
length. When painting, note the
highlights that may be present.
However, such details should
always be seen within the context
of the whole hand, and indeed the
whole pose, if they are not to
become annoying distractions.
Shadows between fingers tend to
be reddish, sometimes with
reflected light bouncing back into
them from the adjacent finger.

Do not neglect the wrist, if it is
visible, with its many small bones.
It is often these linking areas such
as ankles, wrists, and necks, which
are considered less important and
thus do not receive sufficient
attention. In fact, they are crucial to
the posture of your sitter, and you
neglect them at your peril.

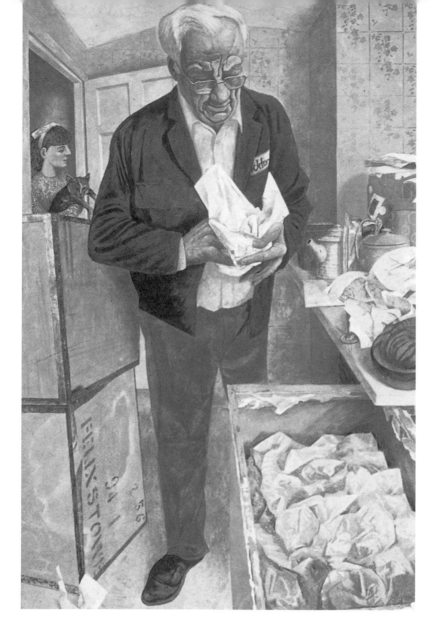

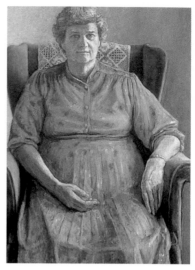

ABOVE Ros Cuthbert, *Portrait of the artist's mother* (oil on canvas), 16 x 12in.
There is more of a sense of solidity and weight here, one hand at rest palm uppermost and the other suspended at the wrist. Textural detail of the skin on hands is an important indication of age and perhaps of character.

LEFT Ros Cuthbert, *Cyril Dowzell, Removal Man* – detail (casein on board), 72 x 48in.
These hands are caught in the act of wrapping an object. Casein can be made with powdered milk and ammonium carbonate. Similar ingredients were used by painters in ancient Egypt.

RIGHT Ivy Smith, *Portrait of Sir Richard and Sir David Attenborough* – detail (oil on board), 60 x 49in.
The hands have a central role in this striking portrait which was commissioned by the National Portrait Gallery, London, when Ivy won first prize in their annual competition. (The complete portrait can be seen on page 126.)

ARRANGING HANDS

In most portraits, the hands are at rest and if they are not too foreshortened will present less of a problem. If you can, arrange the hands a little so that they are easier to draw. Later on you will want to try more difficult arrangements of fingers. Try arranging your model with her hand supporting her head or chin, or with the hand raised in a gesture or holding an object. It is interesting to experiment with the role of the hands.

In some famous paintings, the hands are quite theatrical, as for instance, in Rossetti's painting of *Proserpine* (1877) where the left hand holds a pomegranate and the right languorously clasps the left wrist; or in Ingres's portrait of *Bonaparte as First Consul* (1804) in which Napoleon's left hand is hidden under his jacket while the right points meaningfully to a large document on the table. In Holbein's lovely painting of *Christina of Denmark* (1538) the subject's

delicate hands hold a pair of gloves across her front, suggesting grace and shyness, fit for a likeness to be shown to King Henry VIII of England in his search for a new bride; while the hands of Cézanne's *Woman with a Coffee Pot* (1890–94) are the capable hands of a peasant woman resting heavily on her lap.

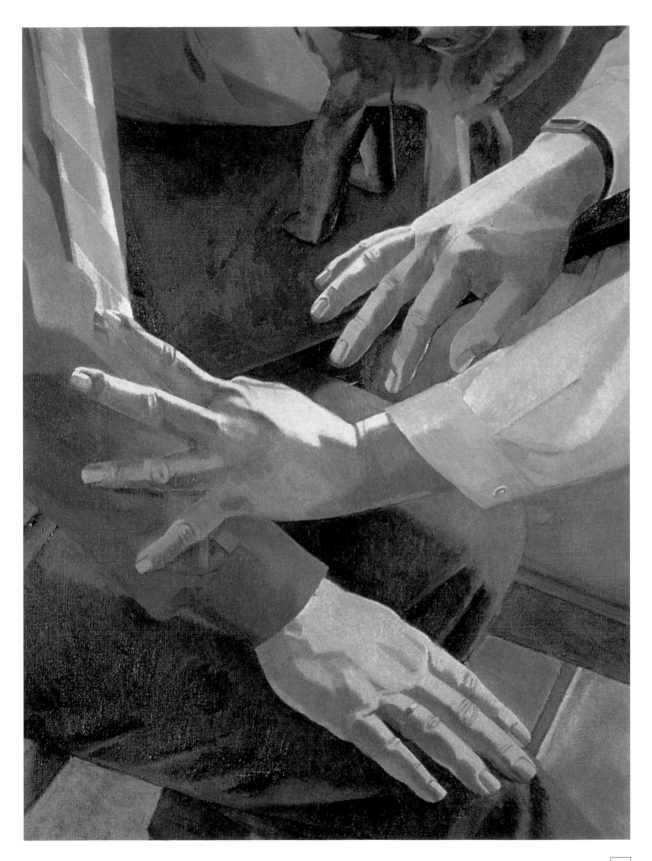

8

HAIR, SPECTACLES,

AND MAKEUP

Most of us have hair, many of us wear spectacles and some of us use makeup. Although hair is a natural feature it is seldom left to grow naturally and is usually a statement of personal style. Specs and makeup are further opportunities for individual expression. As portrait painters we empathize with our subjects' sense of themselves which finds expression in various ways, consciously, or unconsciously. We try to capture not just the likeness but the way our sitter presents him or herself to the world.

HAIR

It is important to retain a sense of the skull beneath a head of hair, however wild and glorious it seems. When drawing in preparation for a portrait I am careful to note, or to sense if I cannot actually see, the skull's contour; and to paint the hair in relation to it. For example, if there is a parting it will follow the curve of the skull. Wherever the hairline is visible it should be painted sufficiently softly to suggest hair growth rather than a wig.

Mix the tone color you see in the hair, perhaps a mixture of flesh tint and hair color. Too hard a shape will look totally false. It could be that the hair grows more thinly in some places. This should certainly be observed because the hairline defines and frames the face and an incorrect emphasis would jeopardize the likeness. In sharply focused, detailed portraits, brush marks should follow the direction of hair growth. Practice will show you how much detail is advisable. Use a very fine brush for single hairs and keep the paint thin. Too much detail can easily look fussy. A few simpler marks over an underpainted base might suffice. It all depends on your style.

A head of hair can be a complicated mass of curls or waves, and as such very confusing to the eye. One way of coping is as follows. Draw in the main leading edges and shapes of locks of hair with the point of a brush. Next, block in the darks with a broad brush – a flat or a filbert. Paint in the most prevalent tone color of the hair elsewhere and begin to blend these together, looking for changes in the hairs' colors due to natural coloring or an increase of

LEFT Brian Luker, *Profile of a young woman* – detail (watercolor), 16 x 12in. The hair has been treated boldly, the first wash going on wet into wet. Darks were added once this had dried.

BELOW Jane Bond, *Harriett* (oil on board), 27 x 25in. In this delightful painting a burnt sienna underpainting warms the dark values of the hair. The golden highlights are painted wet into wet to achieve this soft, silky appearance.

OPPOSITE PAGE Anne Hicks, *David Royce* (gouache on paper), 21½ x 14½in. Because gouache is opaque it can be handled a little like oil paint, laying darks on first and then going in with pale highlights.

shadow. Finally, paint the lighter areas and the sheen or highlights. The movement of the paintbrush should follow the wavy lines of the hair – look for the areas of light and shade rather than the details; these can be suggested last. Do not forget that too much detail is often distracting and looking at your subject with half-closed eyes helps to simplify things.

Hair is often "styled" and this can feel as though you are painting someone else's artwork or sculpture. Care should be taken to observe correctly angles and planes in the haircut, and look for differing textures in the same cut. Some haircuts incorporate both long and close-cropped hair and these extremes are bound to be different in color and texture.

I once painted a young woman who had quite long, straight hair. Well into the painting of her portrait she arrived one morning with a "poodle" perm. I was pretty amazed, and even more so to learn that she had not thought it would make any difference. There was no alternative but to repaint the "new look." Not only had her hair undergone a transformation, but much more of her face was visible, changing the emphasis of her features. Such is life!

Eyebrows and eyelashes should not be painted too heavily, and differences in length and thickness of the hairs should be noted. To a skilled hand the eyebrows can be a single stroke beginning at the inside, which is generally denser and wider, the lessening of paint on the brush coinciding with the petering out of the eyebrow. However, an eyebrow is not necessarily a single continuous arch but might be angled like a circumflex, or even quite straight.

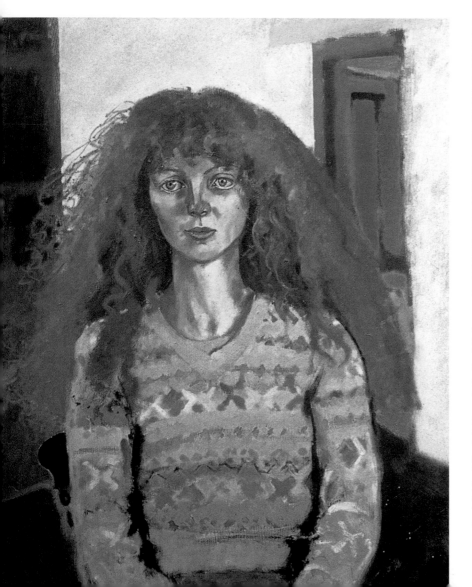

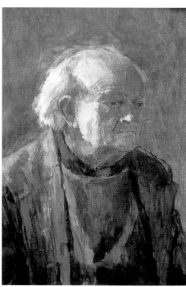

ABOVE Helen Elwes, *Fergus* (oil on board), 16 x 12in. This old man's fine hair is portrayed using semi-opaque touches of pale gray over the darker background around the subject's head.

LEFT Jane Percival, *Stephanie* (oil on canvas), 36 x 20in. The fiery oranges in this portrait are further activated by complimentary blues. This gorgeous head of hair was painted using many different kinds of mark and both the tip and side of the brush. To evoke all this the brush had to race across the canvas.

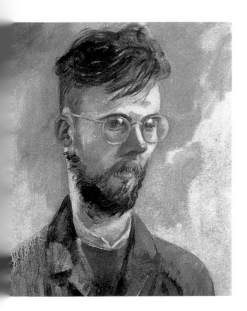

ABOVE **Ros Cuthbert,** *Gerard*
(oil on canvas), 12 x 10in.
The paint was kept very thin in this
study, which took about an hour to
complete. The work depends on thin
washes of paint and fast brushwork
for its liveliness.

RIGHT **Jane Percival,** *Raymond*
(oil on board), 28 x 20in.
In this study, the pale flesh contrasts
dramatically with the dark hair and
beard. Here and there flesh tints are
visible beneath thinner beard growth.
In these areas dark paint has been
scumbled over the dry flesh tint.

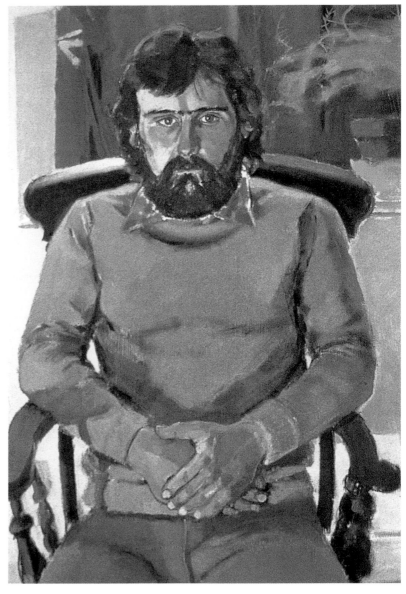

Along its length the direction of
hair growth will vary, nor will the
top edge be exactly parallel to the
lower. Do not lose the "spring" of
the shape in your concern over
individual hairs.

Remember that the eyebrow
follows the contour of the ridge of the
forehead. The position of the
eyebrow relative to both nose and
eye should be correct, as any
inaccuracy here can result in a
change in likeness and/or expression.

Beards are always interesting to
paint, from the wild, untrained
variety to the clipped, manicured
type. I am always intrigued to see
which parts of his beard a man
decides to keep or shave. There
really are a million approaches to
beard gardening!

Basically, a beard can be treated
in much the same way as a head of
hair. Firstly, a man's beard may well
be a different color and certainly a
different texture from his hair. Also,

the beard's hairline is bound to vary
in density around the face and
special care should be taken to mix
the correct tone color for these
areas so that the beard looks
natural. If partly shaved, the skin
showing may be bluish, especially if
the man is dark-haired. If your sitter
has a mustache, consider its
relation to the upper lip, which it
may even obscure, and remember
that its shape will follow the
contours of the face.

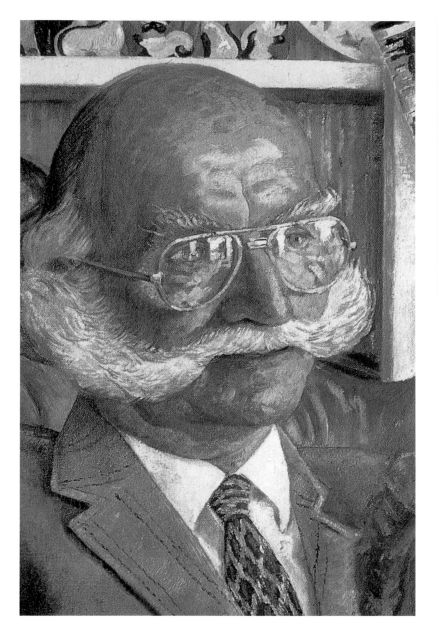

**ABOVE Robert Maxwell Wood, *Self Portrait* (oil on canvas), 16 x 12in.
Max's spectacles are tinted green, transforming the flesh tints. The black frames are carefully drawn, contrasting with painterly handling elsewhere.**

**LEFT Ros Cuthbert, *Ray Trapnell* – detail (oil on canvas), 42 x 30in.
Ray's flamboyant mustache was great fun to paint. The brushmarks are very short across the upper lip, which is almost concealed. The relationship between the mustache and slightly open mouth was difficult to capture. The reflections in his spectacles were very strong and I had to be careful that his eyes were not lost behind them.**

SPECTACLES

Beginners often make the mistake of trying to draw a head first and then putting the glasses on it afterwards. They think of the glasses as being separate, which of course they are in practical terms. But to a painter they are as much a part of the face as the nose. Therefore, include them along with the eyes and nose among your first marks, and integrate them properly into the sculptural unity of the head.

Spectacles do present a considerable additional challenge, not least because they make the eyes more difficult to see and in extreme cases greatly enlarge or reduce their apparent size. The best advice is to look carefully (as usual) and paint only what you can see. Beware of invention, that is, what you "think" you see, rather than what you see, and be on the lookout for the effects of foreshortening on the frames. If the eyes are too hidden in shadow, introduce extra lighting at a lowish angle. But it may also be that the lenses focus extra light toward the eye. Frames will cast shadows and lenses contain reflections. Both shadows and reflections are an inevitable part of the effect and should be accepted and enjoyed – not "removed."

An interesting effect of the refracting power of a lens is noticable where the edge of the face appears inside the far lens in a three-quarter view, and even in a full face view if the sitter is very shortsighted: the line of the face's contour will be broken inside the lens where it will reappear nearer the nose – if the sitter is shortsighted. If longsighted, the contour may not appear at all.

Spectacle frames can be flamboyant or eccentric in design, or else very subtle. Keep a sharp eye on any design quirks; for example, the lower rim of the glasses may be narrower than the upper, and curves may vary from one side to the other. In a three-quarter view you will notice that the frames are not quite flat but follow the curve of the head – so the far lens will be more foreshortened than the near one.

MAKEUP

Like spectacles, this is also a source of concern to many students of portraiture because it is "added". The advice remains the same: paint what you see. Actually, it is great fun to paint a woman – or man – wearing makeup. There is always a sense of display or disguise about it. Some identify so strongly with their "face" that they never step outdoors without it. Makeup can also change an appearance in unintentional ways. For instance, there is often something poignant or endearing about an old woman wearing bright red lipstick and blue eyeshadow. Too much can make someone look tawdry rather than elegant or sexy, as they intend. Business women wear it to look sharp and bright, and teenagers

ABOVE Ros Cuthbert, *The Reverend Alan Grange* – detail (oil on canvas), 60 x 42in.
These glasses created shadow because of the heavy frames but they also focused extra light on to the subject's face – a tricky combination.

ABOVE Jane Percival, *Victoria No 5* (oil on canvas), 20 x 16in.
A fast painting which captures the mood of fun between artist and sitter. The clown makeup is boldly blocked in.

wear it to look sophisticated or wild.

Makeup enhances, exaggerates, and draws attention to the wearer, so it is this which a portrait painter celebrates. The extra-dark eyebrows, long lashes, lustrous cheeks, full lips – none of these presents a problem if it is accepted at "face" value! So allow yourself to be fooled. An interesting experiment is to paint a friend first without, and afterward, with makeup on. Children enjoy fantasy makeup – try asking a child to sit for you made up as a cat or butterfly. Failing this you can always have fun painting a self-portrait, made up as a clown or beauty queen. Makeup may exaggerate, but it can equally well disguise.

DOMENICO

Oil on board, 13 x 10in

R O S C U T H B E R T

Domenico's long hair and his short beard were an interesting challenge. I had to imitate the hair growth with my brush marks, using long fast strokes for the hair and short, deft marks for beard and mustache, blending beard color and flesh tints together where the hair growth was thin.

PALETTE

titanium white

lemon yellow

raw sienna

raw umber

cadmium red

magenta

Indian red

turquoise (pthalocyanine)

cerulean blue

cobalt blue

Mars violet

1 The imprimatura is a mixture of titanium white and raw umber applied several weeks previously. I begin the portrait with cerulean blue thinned with turpentine, working broadly to establish the composition.

2 I keep the paint thin while adjusting the underpainting.

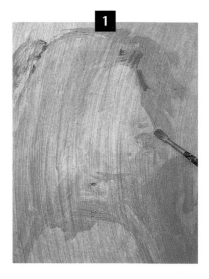

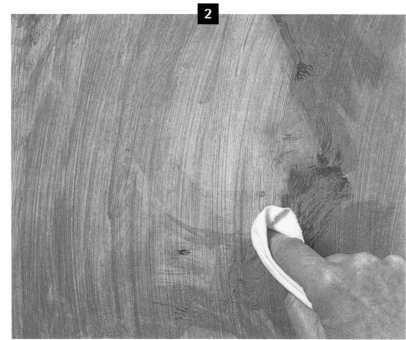

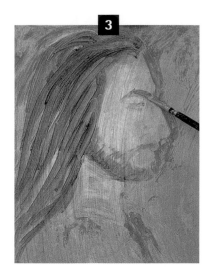

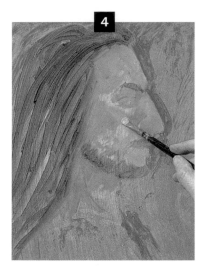

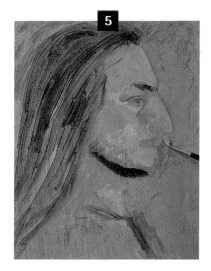

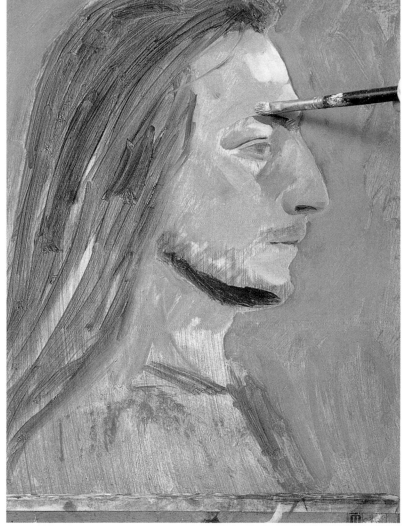

3 Using raw umber and a little Indian red, I establish the likeness and block in the hair and beard.

4 The flesh tint – a mixture of titanium white, cadmium red, and cobalt blue – is applied next.

5 I roughly block in the dark areas of beard and eyebrow and more fully model the eye. Then I paint in the background using turquoise and white, making small adjustments to the profile as I go.

6 The head is modeled using admixtures of white, cadmium red, and cerulean, with an occasional small dab of lemon yellow.

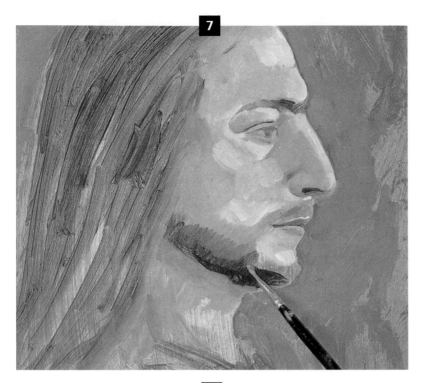

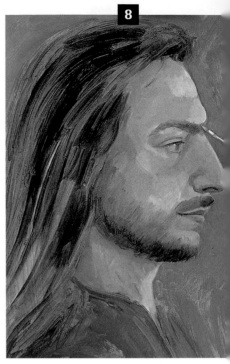

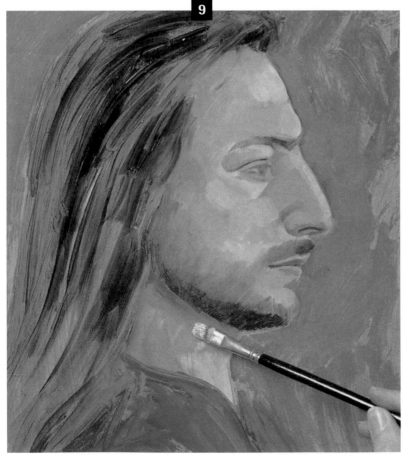

7 I darken the beard with a mixture of raw umber and Mars violet, and begin to blend together the flesh tints and shorter beard growth. In the shadow areas under the beard and close to the hairline, cobalt blue is added to the flesh tint.

8 Now I add darker values to the hair using mixes of monestial turquoise, raw umber, raw sienna, and Indian red. For the shirt I use first a darker, then a paler cobalt blue. I continue to model the forms using variations of the flesh tint, and to blend adjacent values where necessary.

9 Areas such as the thin hair growth between the eyebrows need careful observation and delicate treatment.

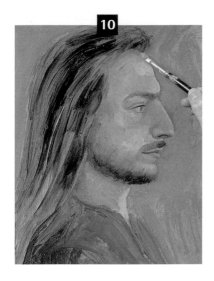

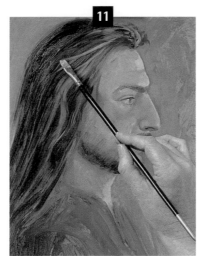

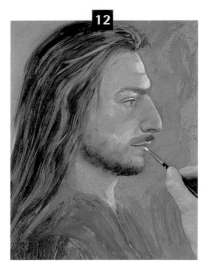

10 Another subtle area is the hairline. Here, I blend forehead into hair using the flesh tint plus raw umber.

11 Paler tints are added to the hair next. A mixture of white, lemon yellow, and raw umber indicates lighter hair growth, while white, cobalt blue, and raw umber mixed together suggest highlights.

12 Finally a highlight of magenta mixed with white is added to the flesh tint in a band down the front of the face, close to the profile.

13 The finished painting.

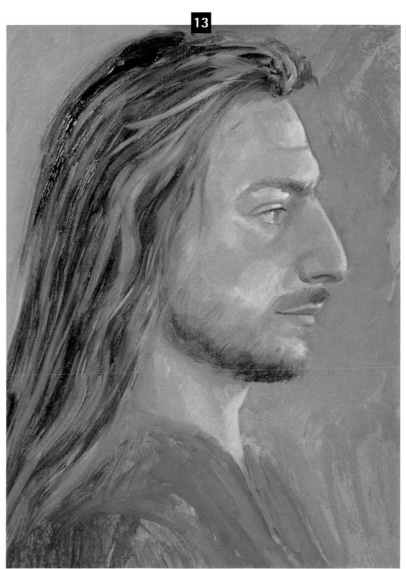

9

CLOTHING, JEWELRY, AND HATS

H ATS, JEWELRY, AND CLOTHING CAN ALL HELP TO DESCRIBE VOLUMES SUCH AS WRIST, THROAT, NECK, OR HEAD AND MAY GREATLY ADD TO THE CHARM OR DRAMA OF A COMPOSITION. WHERE WOULD HALS'S 'LAUGHING CAVALIER' BE WITHOUT HIS HAT?

YOUR SITTERS MAY ASK TO BE PAINTED IN CERTAIN CLOTHES AND THEIR CHOICE WILL BE A FAIR INDICATION OF THE TYPE OF PORTRAIT THEY HAVE IN MIND, DETERMINING WHETHER THE PICTURE IS TO BE FORMAL, IMPRESSIVE, WITTY, INTIMATE, OR RELAXED, ETC.

PRACTICE STUDIES

Clothing is difficult to paint if you are afraid of painting folds in cloth, and if this is the case, some special practice would be wise. Throw a non-patterned dress or coat over a chair and make studies, both in pencil and paint, of the way it hangs. Heavy fabrics will hang in bulkier folds, shiny ones will have bright, sharp highlights, diaphanous ones will show in layers of graduated tone color. Velvet is discernible from woven tweed because it holds more light in the pile. Creases in satin are likely to be more brightly, sharply highlit than creases in cotton. Having drawn in the contours, find and paint the darkest parts, then paint in the brighter areas and finally the highlights. A simple method such as this can be a good place to begin.

Clothing is often painted simply in portraits so as not to detract from the face. The degree of emphasis is up to you, but begin by mastering plain fabrics before tackling patterns, stripes, and textures. Clothing offers all kinds of delicious possibilities for composing with color and pattern. However, it is interesting too, to see

BELOW LEFT Hugh Dunford Wood,
Portrait of a woman **(oil on canvas),**
44 x 21in.
Hugh has used thick paint and bold handling in this study. Stark lighting has created dramatic light-dark contrasts. Note how the stripes in the woman's skirt are omitted in the shaded area.

BELOW RIGHT Jack Seymour, *Janet* **(oil on board), 23 x 15in.**
Janet's cotton shirt is painted in three basic shades of white, pale gray and mid-gray. The skirt, apparently made of heavier fabric, hangs in simpler folds.

OPPOSITE PAGE Robert Maxwell Wood,
Portrait with shaded eyes **(oil on canvas),**
16 x 12in.
A peaked cap provides a bold contrast to the more broken handling of the face. Its floppy peak casts a broad shadow which provides a color link between hat and face.

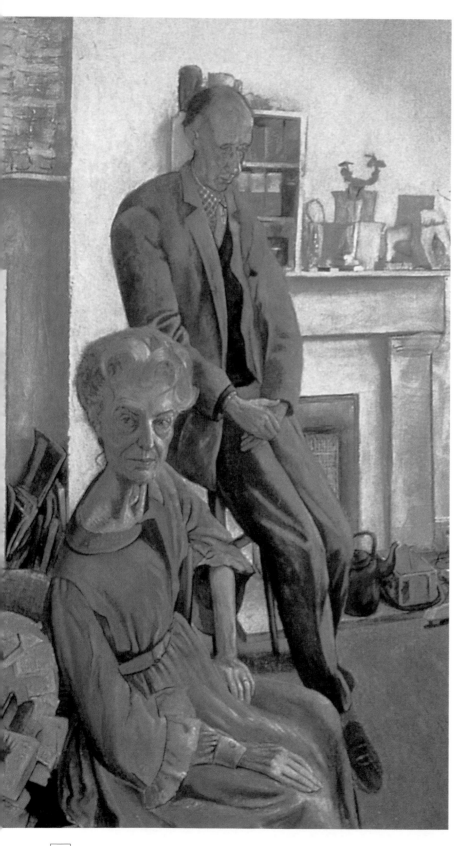

that a great master such as Rembrandt often suppresses the light on his sitters' costume in order to "spotlight" the head. The difference in emphasis could distinguish a "psychological" portrait from a decorative one.

OLD MASTERS

Ingres's wonderful portrait of Madame Moitessier (held by the National Gallery, London) is the work of a master whose preference was to suppress all signs of brushwork in his pictures. He loved sumptuous fabrics, pattern, and heavy jewelry, and painted in great detail. However, we are told that this portrait gave him endless trouble and took 12 years to complete, which he did at the age of 76. Another artist with a passion for closely observed finery was Agnolo Bronzino. His portrait of *Eleanora of Toledo* (held in the Uffizi, Florence, Italy), shows a beautiful woman wearing a dress covered in pearls and gold thread.

LEFT Ros Cuthbert, *Cecil and Elizabeth Collins* (oil on canvas), 42 x 24in. The couple's clothing is treated in a simplified manner in keeping with the style of the painting. Here and there, charcoal underdrawing is still visible.

ABOVE Robert Maxwell Wood, *The exercise swimmer* (oil on canvas), 22 x 17in.
Here, undulating lines on the swimsuit follow the forms of undulating flesh. The hat adds a humorous touch.

RIGHT Ros Cuthbert, *Cecil Collins at the Central School of Art (England)* (oil on canvas), 78 x 24in.
Here, the contrasting qualities of the fabrics (felt, tweed, and leather) are an important part of the painting.

LEFT Ros Cuthbert, *The blue crown* (watercolor with gouache), 30 x 22in. This painting was done from a small drawing. The sparkle of brocade is added with white gouache over watercolor washes. At the back of my mind were captivating portraits by Velasquez of the Infanta Margarita.

BELOW Barry Atherton, *Portrait of the painter Susan Steele* (pastel), 44 x 30in. In this flamboyant portrait, Susan's left leg is discernible under her dress because the white polka dots follow its contours. The many bracelets, the hat, and striped pantyhose all add to a sense of playful display.

Gloves have been much used as "props" in portraiture, worn on both hands or one hand, or held to suggest languor or coquetry, for instance. A hand holding a glove in a formal portrait can lessen that sense of distance between the viewer and the viewed, as if the subject had just entered and is removing his outdoor clothes. Fans also are eloquent, and even shoes can tell a story.

As for hats, paint them to suggest romance, mystery, humor, serenity, and so on. They are full of marvelous possibilities.

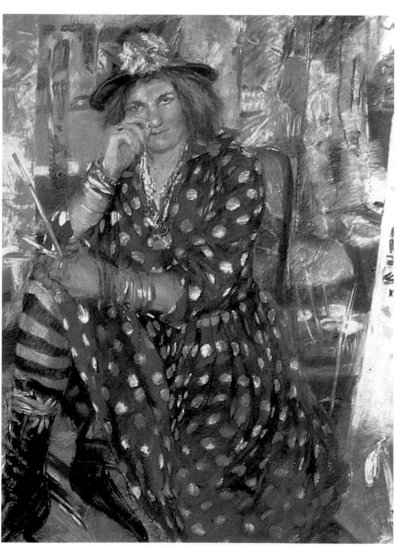

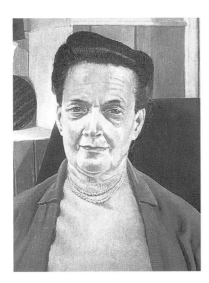

ABOVE Jack Seymour, *Mrs Blackmore*
(oil on board), 12 x 8½in.
The soft shine of a pearl can be
indicated quite simply. Here, the
darkest value is almost in the center of
each pearl. Beneath the necklace the
woman's sweater reflects upwards
creating a lighter, warmer value, while
above it the highlight is white.

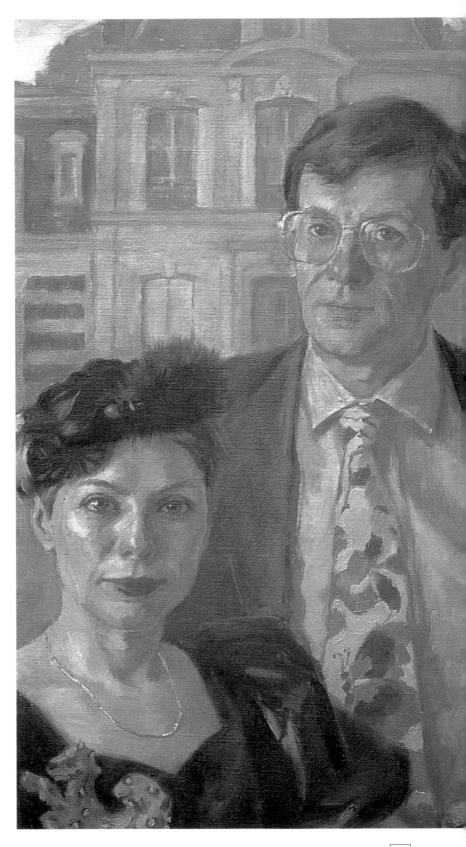

ABOVE Juliet Wood, *Monsieur et Madame
Breyton* – detail (oil on canvas),
28 x 24in.
Madame Breyton's simple necklace
attractively describes her collar bone
and chest. The hat, with its feathers
and pin, is worn at a jaunty angle, but
these details of her costume do not
detract from the more strongly lit face.

10

WATERCOLORS AND

PASTELS

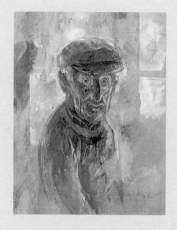

WATERCOLOR AND PASTEL ARE MEDIUMS WITH SHARPLY CONTRASTING CHARACTERISTICS, ONE WET AND FLOWING, THE OTHER DRY AND GRAPHIC. IN THIS CHAPTER I DEAL WITH EACH ONE SEPARATELY, BUT THEY CAN ALSO BE PLAYED OFF AGAINST ONE ANOTHER IN THE SAME PAINTING TO ACHIEVE EXCITING AND UNUSUAL EFFECTS. WATERCOLOR WASHES CAN PROVIDE A TINTED SURFACE ONTO WHICH PASTEL MAY BE LAID. OR THE PORTRAIT COULD BE MORE FULLY DEVELOPED AS A WATERCOLOR USING PASTEL TO TOUCH IN THE DETAILS AND ADD TEXTURE. INTERESTINGLY, PASTEL CAN BE TURNED INTO PAINT SIMPLY BY BRUSHING WATER INTO IT ON THE PAPER. THIS APPROACH MIGHT BE ESPECIALLY USEFUL FOR ESTABLISHING THE UNDERPAINTING.

WATERCOLORS

Many people think watercolor is not a medium for portraiture. The reason for this is that the ideals of freshness and freedom in watercolor technique are so hard to combine with the discipline of portraiture. And yet when it works, it is pure magic: the luminous quality of flesh perfectly caught by the light, sparkling washes of color. I would not, however, recommend watercolor portraiture until you are already a confident watercolorist and have developed your drawing skills.

As with any medium, a watercolor portrait can be anything from carefully drawn and closely detailed, to free and spontaneous. If you lack confidence to draw with the brush, draw the contours and likeness in lightly with a pencil, taking care not to bruise the paper and erasing as little as possible – this can damage the fibers of the paper, which will show when you paint. Apply dilute washes, using wet-into-wet techniques to intensify color or tone, or else laying one wash over another waiting for each to dry first. This

BELOW Brian Luker, *Errol* (watercolor), 16 x 12in.
Brian first makes a sketchbook study of his model, then he does a larger pencil drawing on stretched, cold pressed paper. He works wet into wet, avoiding hard edges except where there is a natural fold or crease in the skin. Details such as wrinkles and eyelashes are added when the washes have dried.

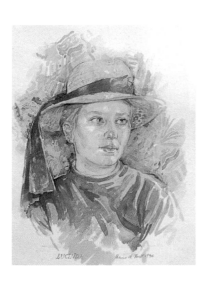

ABOVE Pat Hares, *Lucinda* (watercolor), 15 x 11in.
Pat worked on this painting in the evening light, using 200lb cold pressed paper, unstretched. She made several free studies with the brush, then began the painting with pencil. The wash for the face was mixed with light red and cadmium yellow and was painted more or less in one go.

OPPOSITE PAGE Ros Cuthbert, *Portrait of Tom* (watercolor with gouache), 18 x 14in.
Tom sat in front of the window, his head backlit by the green glow of sunlit grass. I painted him with cadmium scarlet, ultramarine, and Prussian blue watercolors, with touches of lemon yellow and white gouache to complete the highlights.

can be done three or four times without losing too much freshness as long as each wash is painted without disturbing underlying ones. This requires fluent handling – no going back to fuss over it. Details such as eyelashes, eyebrows, and lips can be added once the flesh tints are quite dry.

Victorian portraits are often painted with extreme attention to detail. Gum arabic was sometimes added to the paint to stiffen it, which would increase control in all techniques. Watercolor can be combined with gouache to achieve a more opaque effect.

WATERCOLOR EQUIPMENT

Use artists quality watercolors and the best quality brushes you can afford. Personally I enjoy using Chinese brushes with watercolor for their versatility though they lack the "spring" of a sable brush. Watercolor paper blocks and books are useful for sketching but the best way, unless you are using very heavy paper, is to wet-stretch a sheet of paper with gum strip onto a drawing board. This prevents the paper from wrinkling and the paint from "pooling". Experiment with different makes, weights and textures of paper to find what suits you best.

ABOVE Sets of watercolor paint in tubes and pans. Watercolor papers made up into books and blocks. Paper is sold in a variety of surfaces and thicknesses.

**LEFT Rachel Hemming Bray, *Tailors, Bill and Harry*, Bristol Old Vic (watercolor), 6 x 4in.
Rachel delights in recording people at work and always paints from life, sometimes working in cramped or awkward conditions. This painting was done in a tiny corner of a tiny room filled with expensive fabrics.**

INGRID

Watercolor on cold pressed paper, 22 x 15in

R O B E R T M A X W E L L W O O D

Max captures Ingrid's pale hair and complexion by using
very delicate washes and making the white
paper do some of the work.

PALETTE

aureolin

cadmium orange

cadmium red

carmine

Windsor violet

cerulean blue

ultramarine

emerald green

viridian

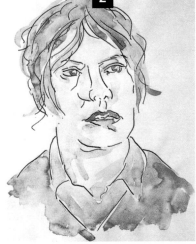

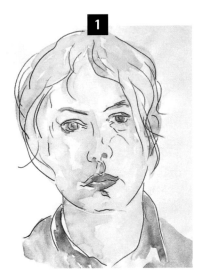

1 and 2 Max began by doing two
fast studies which took just a few
minutes each.

3 He starts by drawing in the likeness
with a 3B pencil. Then he proceeds to
paint in very dilute washes, using
aureolin for the hair and a mixture of
Windsor violet and carmine for the
flesh tints.

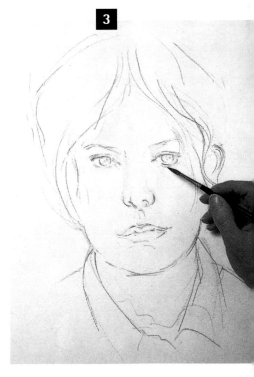

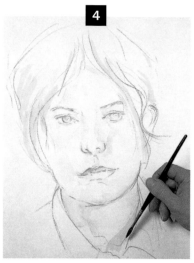

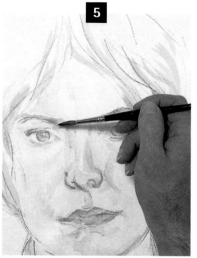

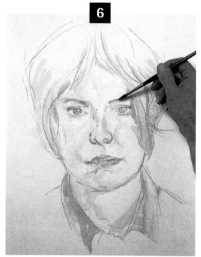

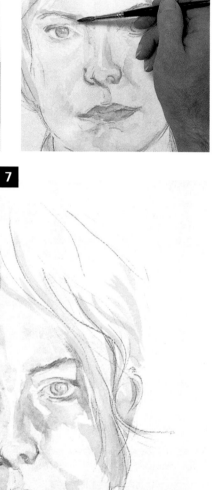

4 The shadow on the neck is added with a mixture of aureolin and viridian. Throughout the painting Max works with a number 7 sable brush.

5 He uses a mix of ultramarine and cerulean blue for the eyes, working around the highlights. Then he deepens the flesh tints with Windsor violet and cerulean on the nose and chin and around the eye sockets.

6 Max touches in the eyebrows with a mixture of cadmium orange and emerald green.

7 The lips are deepened with a wash of Windsor violet and carmine, cooled and darkened for the mouth line with violet and ultramarine.

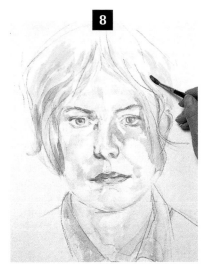

8 The hair is now developed using strokes of orange mixed with emerald in varying proportions and with a few light touches of very dilute viridian. The shadows around the temples are a mix of violet and orange. The eyes receive a deeper wash of ultramarine dulled with orange.

9 The hair is shaded next using a mixture of ultramarine, violet, and orange. One or two touches of a flesh tint, mixed with carmine and orange, are added along the line of the jaw and down the shadowed side of the face. Finally, a pale wash of cadmium red is applied to the skin above the upper lip.

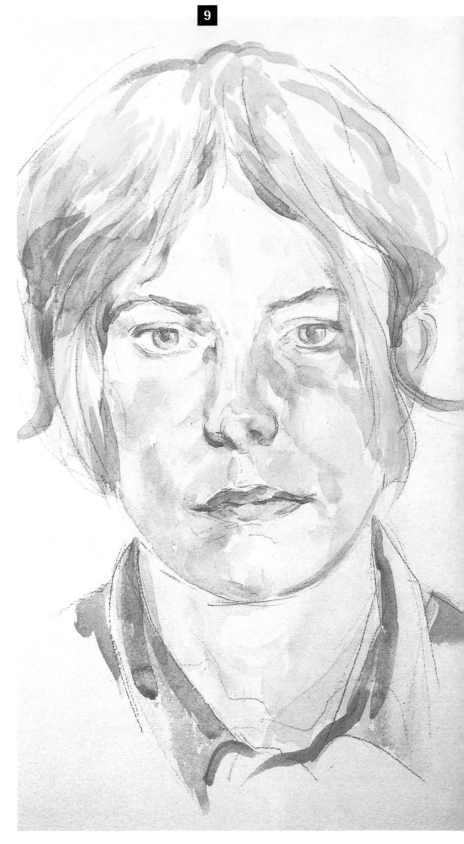

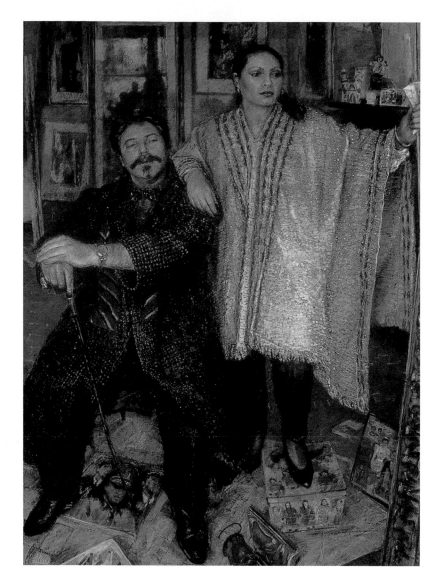

PASTELS

This is a highly recommended medium for beginners in portraiture, being a form of drawing but with possibilities for the rich color and painterly texture of a painting medium. It is easier to control a stick of dry pigment than a brush of liquid paint, but the difficulty you will probably encounter with pastel is finding the right tone color for the job. Unless you have a very large collection of different pastels you are going to have to use overlaying and blending techniques to create new colors.

Begin by drawing with fine or medium charcoal, or a pastel pencil. A sanguine pastel pencil is ideal. Tinted papers are useful – a cool shade such as mid gray, gray blue or gray green will enhance flesh tints, but warm shades should also be experimented with. Dark papers will give a more somber mood. Charcoal underdrawing should be fixed or lightly brushed until all loose particles are removed and your image is pale but still discernible. Loose charcoal will dirty your flesh tints. Having decided which of your pastels is best for the half tone apply this first, followed by the main flesh tint. Whether or not you decide to blend these colors together is up to you. A smoother effect is obtained by blending but overblending can result in a pasty or smeared appearance. So blend too little rather than too much. With experience, you will see that rich, dense textures can be achieved by working one tint or shade into another.

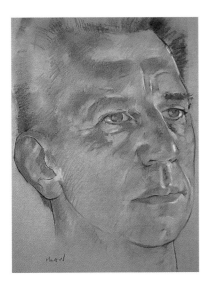

ABOVE Robert Maxwell Wood, *Head of Errol* (charcoal and pastel), 21½ x 15in. Max drew on a half sheet of pinkish gray pastel paper first in charcoal and with soft pastel. Some marks have been softened by rubbing with a finger. Black chalk linework firms up the contours here and there.

RIGHT Ros Cuthbert, *Portrait of Tomasin* (pastel), 30 x 20in.
For this portrait, I stretched a piece of cold pressed watercolor paper and laid on a dark gray wash with Chinese ink. When this was dry, I drew first with charcoal and then worked loosely with soft pastels to keep a painterly appearance.

Two great pastelists worth looking at are Chardin and Manet. Chardin produced his pastel portraits with loving care, laying on the colors in thin parallel strokes. Manet's fluent handling involved brushing one color into another for a soft atmospheric surface, blending in the lights and shades.

Degas must have produced the best loved of all pastels. He made superb use of the richness of color and texture this medium offers but his portraits and figures never lack psychological presence.

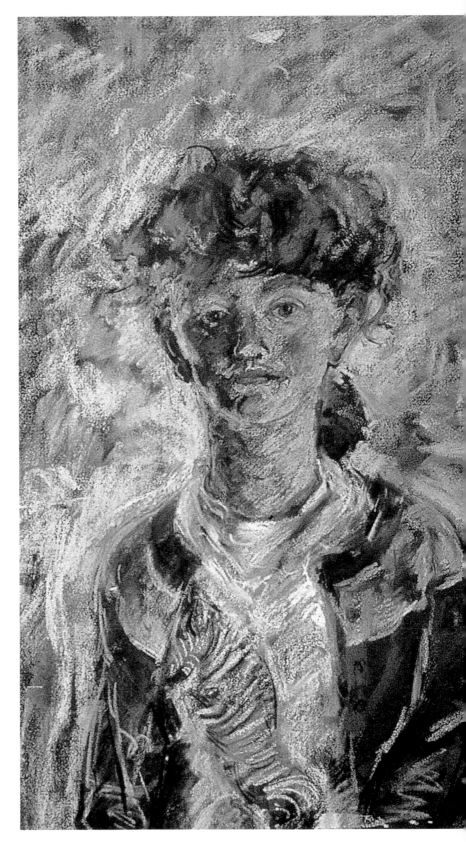

PASTEL EQUIPMENT

Pastels come in different degrees of hardness or softness. Hard pastels are usually square sticks, soft ones round and thicker. Some makes are softer than others. There are also pastel pencils, useful for initial drawing and for spotting in fine details. You do not have to work on pastel papers – fine sandpaper sheets are sold for pastel work as well as some specially prepared boards; or you can experiment with your own painted surfaces.

RIGHT Boxed sets of pastels.

BELOW Rachel Hemming Bray, *Portrait of Peter Reddick* **(charcoal, white gouache, pastel and watercolors), 14 x 19in. Watercolor and pastel used together on a stretched sheet of pale gray paper.**

ANGUS

Pastel on tinted paper, 25 x 19in

D A V I D C U T H B E R T

David uses a warm neutral tinted paper which provides a toned ground
for the pastel colors. Here and there the paper color shows through,
unifying and enlivening the colors drawn over it.

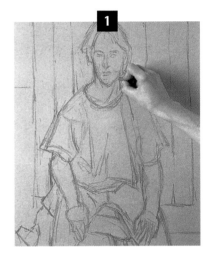

1 Using vermilion, David begins by
drawing in the outlines.

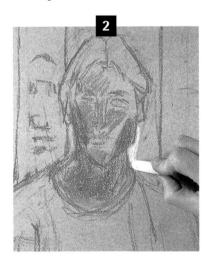

2 He establishes some values on the
face, using pale flesh tint, brown
madder and dark maroon. Then he
works on the background adjacent to
the face using white.

PALETTE		
vermilion		greenish gray
pale flesh tint		terre vert
brown madder		dark greenish blue
red oxide		bright turquoise
yellowish orange		Hooker's green
yellow ocher		dark blue violet
dark pink		dark olive green
dark maroon		viridian
very dark mauve		charcoal
bright purple		black
dark cool gray		creamy white

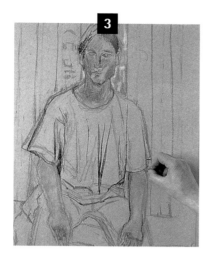

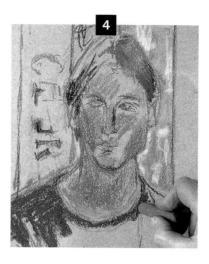

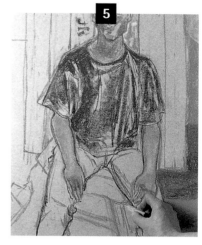

3 Having explored the flesh tints of the arms and hands using red oxide and pale flesh tint, David reaffirms the drawing with Hooker's green.

4 The T-shirt is blocked in next using dark cool gray.

5 Before proceeding too far David begins work on the background, using vermilion, greenish gray, terre vert, black, and a creamy white.

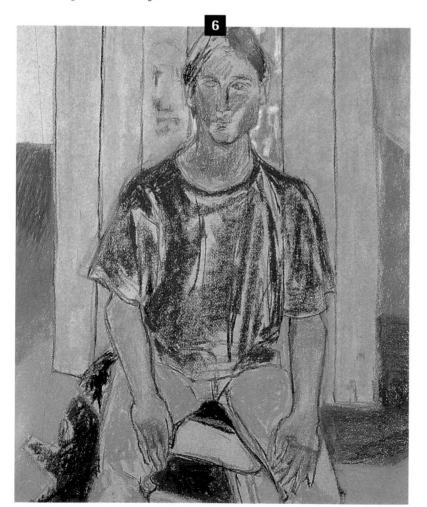

6 At this stage the composition and distribution of tones and colors is clearly mapped out.

7 The T-shirt now receives a layer of dark greenish blue and dark blue violet, and touches of very dark mauve and touches of viridian.

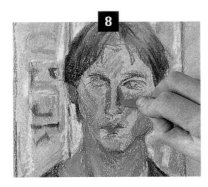

8 The face is modelled using red oxide and blended greens and grays – Hooker's green, dark olive green, terre vert and earth. Also touches of bright purple.

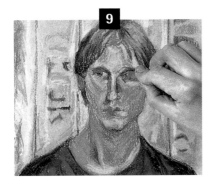

9 The eyes receive touches of charcoal to give a soft dark line.

10 The pants are worked in with strokes of bright turquoise, bright purple and white. Finally, the hands and arms receive yellowish orange, yellow ocher, dark pink, and terre vert.

11 The completed picture.

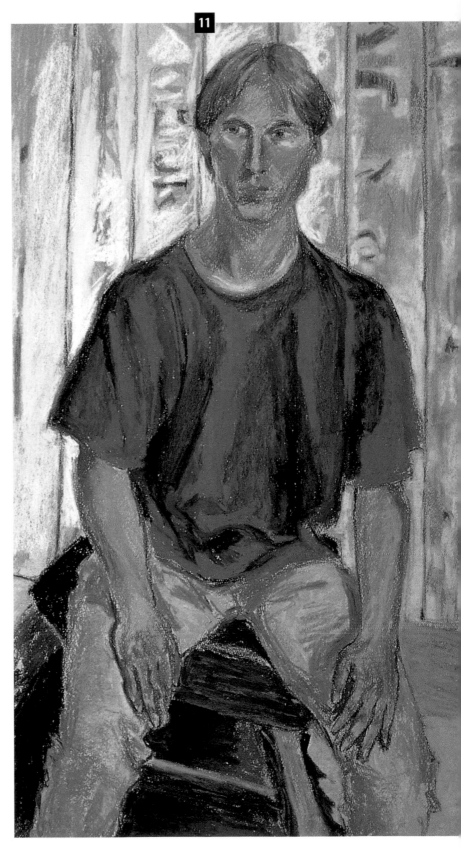

11

ACRYLICS AND OILS

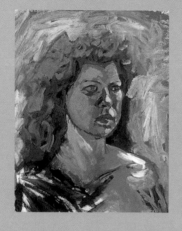

ACRYLICS ARE OFTEN THOUGHT TO BE SIMILAR TO OILS AND THIS IS TRUE UP TO A POINT. BOTH CAN BE USED THINLY MIXED WITH THE APPROPRIATE GLAZING MEDIUMS, OR THICKLY, USING IMPASTO TECHNIQUES. HOWEVER, ACRYLICS ARE FAST DRYING AND OIL PAINT IS A SLOW DRYING MEDIUM. THERE ARE ALSO TECHNICAL COMPLEXITIES TO OIL PAINT SUCH AS VARIABLE DRYING RATES FOR DIFFERENT COLORS. OIL PAINTERS ARE WISE TO STUDY THE CHEMISTRY OF THEIR MEDIUM.

OPPOSITE PAGE David Cuthbert, *Ione* (acrylic on paper), 30 x 22in. David began with thin washes and then worked with thicker paint straight from the tube, using large hog brushes and working with great speed and verve to achieve this energetic portrait.

BELOW Steve McQueen, *Leslie* (acrylic on canvas), 20 x 30in. Steve worked with mat medium on a white ground. An unusual feature is the gold leaf halo. A ground of burnt sienna and crimson was laid down first and the gold leaf applied using Japanese gold size, some of which was overpainted as the painting progressed.

ACRYLICS

Because acrylics are quick drying you can use bright or dark colors for the underpainting and build up layers of paint quickly. Whatever the medium, some pigments are naturally opaque and others are transparent, so it is not strictly true to say that acrylic is an opaque medium and watercolor a transparent one. Oxide of chromium, for example, is opaque whether bound with gum arabic for watercolor or with acrylic medium for acrylic paint, and likewise golden ocher is transparent.

One property of acrylic is its versatility. It can be used in very thin washes like watercolor, when even the opaque pigments are used thinly enough to make them seem transparent, or at least translucent. It can also be built up thickly and with the addition of impasto medium, worked in impasto techniques. It can also be used with transparent gel medium for glazing, a technique familiar to most oil painters. Its quick drying properties might make it a tricky medium for portraiture if you like to spend time blending colors together. But it can be mixed with a retarding medium to slow up the drying rate, giving time to work fresh paint into a wet surface, essential for some portraiture where it is important the "joins" in layers of paint should not be visible.

ACRYLIC EQUIPMENT

Acrylic paints are sold in tubes or tubs and are made from the same pigments used in oil paints but bound with a quick-drying acrylic medium. They are thinned with water and dry to a desirable waterproof finish. Various mediums and extenders are available to alter the consistency, transparency and drying rate of the paint. As with oils, long-handled brushes are for use standing at an easel, and short-handled ones for close work, sitting at a table.

RIGHT Stina Harris, *Sam Falle* (acrylics on paper), 30 x 22in. This study of the artist's father shows how acrylic can be laid on in transparent washes and worked wet into wet as with watercolors. Stina first drew with red brown crayon and then worked swiftly, thinning the paint with plenty of water.

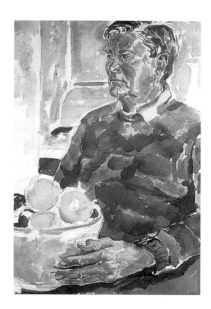

BELOW Acrylic paint in tubes and pots, with a selection of brushes and mediums.

LAURA

Acrylics on paper, 30 x 22in

D A V I D C U T H B E R T

In this portrait of Laura, David shows how to work boldly with acrylics, putting one layer of color over another, correcting where necessary, and achieving an energetic and fresh finish.

1 First of all, David draws in the composition using cerulean blue thinned with water. He works broadly and confidently, knowing that mistakes can be overpainted.

2 He reaffirms the drawing with reddish brown red hue.

3 Then he begins to work in the main color areas around the figure. Here he is using permanent Hooker's green, deep hue and titanium white.

4 The head and arms are filled in with dilute quinacridone red, and a bright lemon yellow is chosen for the chair. The paper is now almost covered with a thin layer of paint.

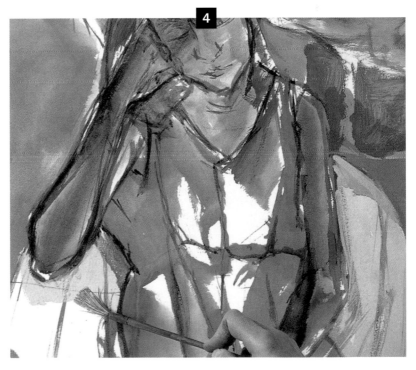

PALETTE

 titanium white

 parchment
(greenish cream)

 raw sienna

 lemon yellow

 neutral gray (mid gray)

 cerulean blue hue

 manganese blue hue

 ultramarine blue

 bright violet

 deep violet

 quinacridone red

 reddish brown

 Hooker's green
deep hue

 turquoise green

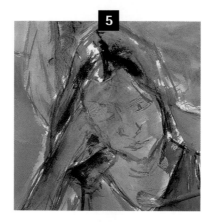

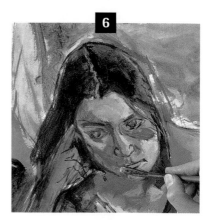

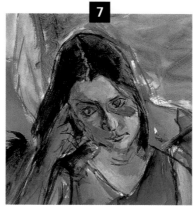

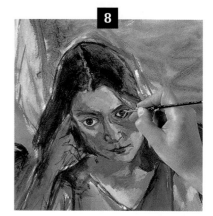

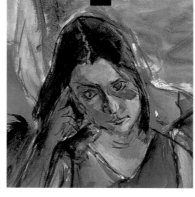

5 Next, David brushes a thin layer of lemon yellow over the red face and arms.

6 The shadows on the face are explored using semi-opaque deep violet over reddish brown, and the drawing strengthened by emphasizing the tonal contrast between the pale face and the dark hair.

7 Here, the shoulder line is being corrected.

8 For the eyes, David uses permanent Hooker's green deep hue, unmixed for the darkest parts, and mixed with parchment for the lighter tints on top of deep violet and reddish brown. For the white of the eyes he uses deep violet and a mixture of parchment and turquoise green.

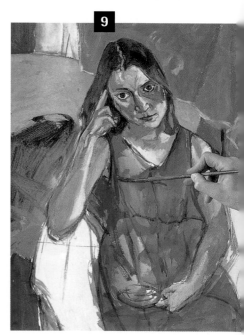

9 Shadows on the dress are blocked in with ultramarine blue on top of a thin underpainting of manganese blue hue.

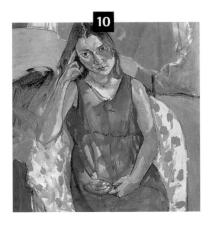

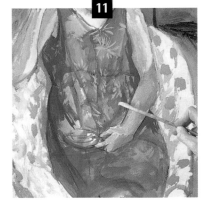

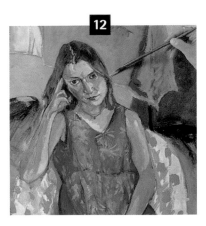

10 At this stage the composition, color harmonies, and likeness are well established.

11 The pattern on the dress goes in next, with a mixture of neutral gray and raw sienna.

12 Adjustments to the background involve toning down the violet drape with a green made by mixing permanent Hooker's green deep hue with parchment.

13 The hairbrush is completed last, the final touch of titanium white being applied with the tip of the brush.

14 The finished painting.

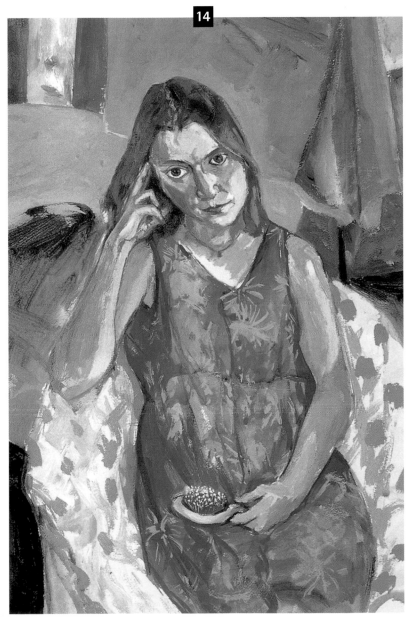

OILS

Oil paint is the traditional medium for portraiture and since the tradition spans seven hundred years there is a lot which could be said. A portrait in oils is traditionally painted using transparent glazes combined with opaque paint.

Glazing is the technique of building up layers of transparent color one over another. If a white ground is used, the full richness and brilliance of the color is retained. If the ground is tinted or colored, transparent glazes will add their own hue to the underpainting. Thus transparent orange over a blue ground will produce brown, and transparent blue over yellow will make a green, to give two simple examples.

Until recently this was a time-consuming process as each glaze had to be left for perhaps several days before it was dry enough to be overpainted. These days modern glazing mediums are fast drying, making oil glazing little more lengthy a business than acrylic glazing. There are many recipes, but a glazing medium I have used is one-third turpentine, one-third linseed oil and one-third damar varnish. This would then be further thinned with turpentine for use. First layers would be thinned more than subsequent ones, following the oil painters' rule of working from "lean" surfaces (ie without much oil) to "fat" ones. This prevents the paint from cracking. Glazing is not usually used by itself for portraiture but is very effective when combined with opaque paint.

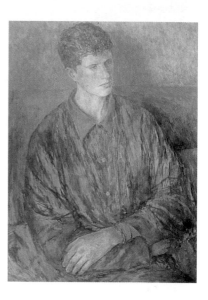

RIGHT Helen Elwes, *Gemma* (oil on gesso), 17 x 12in.
Helen works on a homemade gesso ground. Her recipe is whiting (powdered chalk) mixed with warmed rabbit skin size, laid over masonite with cheesecloth sized over it. Four or five layers of gesso achieve a smooth, absorbent and durable ground.

BELOW Juliet Wood, *Stephen Brown* – in progress (oil on canvas), 30 x 24in.
Juliet worked on a homemade "half-oil" ground using equal amounts of titanium white and calcium carbonate (chalk) mixed with a weak rabbit skin glue (available as a powder from art suppliers.) To this she added cold pressed linseed oil. The amount of oil determines the absorbency of the ground and also its drying time.

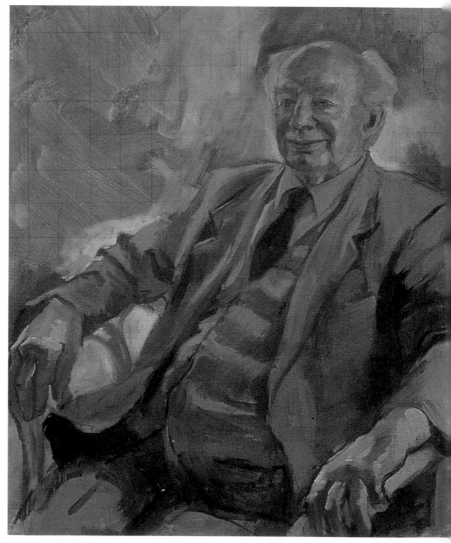

LEFT Rachel Hemming Bray, *George Sweet Painting* (oil on gesso on board), 14 x 10in.
Rachel made the gesso ground for this painting and coated it with rabbit skin glue to decrease the absorbency. The picture was painted while George was at work and took five sittings. Rachel reworked his position, hence the thickly applied paint.

Opaque paint Many artists working this century have developed their style based entirely on opaque use of paint, that is by using naturally opaque pigments and/or mixing them with white. Two of these were the Camden Town (London) artists Walter Sickert and Harold Gilman. The post impressionists Van Gogh, Gauguin and Cézanne also used oil paint in this way. Some artists even drain excess oil from their colors by squeezing their paint on to newspaper for a couple of hours before use. This makes the paint dry to a mat finish and generally gives a dustier appearance to the colors, for it is the oil that gives colors their richness. If too little oil is present though, the paint will be too dry and tend to flake and crack.

Another cause of cracking is if an underlying layer of paint is drying more slowly than a top layer. Some pigments have slower drying rates than others. The umbers, burnt sienna, flake white and Prussian blue are among the fast drying ones, while ivory black and the cadmiums are very slow, with a range in between. It is wise to become familiar with drying rates of

oil paints if this danger is to be avoided.

This might all sound a little intimidating, but oil paint is very long-suffering and can be scraped down and painted over many times.

SUGGESTION FOR A PROCEDURE

In Chapter 4, I suggested a palette setting used by Rembrandt. I would like now to suggest a complete method which if followed correctly will give you a good grounding in sound technique.

It is based on the techniques of artists from the Florentines onward and is in three stages. The first is called the *imprimatura*. This simply involves rubbing or brushing a very thin layer of transparent color over the white ground. Traditionally raw umber, burnt umber or terre verte were used. In Leonardo's unfinished painting *The Adoration of the Magi* (Uffizi, Florence), he used a deep yellow imprimatura. Terre verte, a lovely subtle transparent green, was used as imprimatura for flesh tones by Michelangelo. You can see the logic of it if you look at

the back of your hand. Dull green beneath translucent flesh tint produces the appearance of veins and also helps cool down shadow areas, as well as enhancing the warm tints of the flesh giving the luminosity discussed in Chapter 4.

Having painted the imprimatura, not forgetting to keep it very thin, it should be allowed to dry for a few days. On to this the next stage, the underpainting, is added. This amounts to a careful drawing of the composition and likeness in monochrome – I suggest using thin raw umber paint. Include at this stage a full tonal study, indicating dark areas. It does not matter how long you spend working out the underpainting – thin, wet oil paint can easily be removed with turpentine on a soft rag. It is important to work everything out at this stage so that the third and last stage can be painted with the minimum of correction.

Once the underpainting is dry you are ready to begin working in color – the *alla prima* layer. The instructions on color mixing in Chapter 4 will be useful for this stage of the painting. Working with

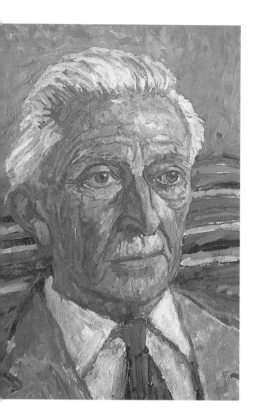

ABOVE Peter Coate, *The artist's father –* detail (oil on board), 24 x 17in. Peter worked from life on a white ground in opaque paint applied in separate strokes with little or no blending of the wet paint. The drawing was restated with a red brown, probably burnt sienna.

thin layers of transparent and translucent paint over the raw umber will help to develop the shadow areas. The flesh tints can be kept thin in places to make use of the imprimatura and applied more thickly to cover it where lighter tints are needed. This method will familiarize you with the roles of transparency and opacity in building up an illusion of solid form.

In spite of careful underpainting you may find the likeness disappearing as you paint the alla prima layer. The paint hides the under drawing, and contours and volumes imperceptibly shift as you work. If this happens, try moving your eyes at speed between your sitter and portrait to see where the shifts have occurred. Looking at your painting in a mirror may help, or squinting at it through half-closed eyes. This cuts out inessential details and could disclose the underlying problem. If all else fails, return to careful measuring. You will find that

portrait painting is always this dialog between correction and development.

OIL EQUIPMENT

Oil paints are usually sold under the pigment name, e.g. cadmium yellow, but sometimes have a name invented by the manufacturer, e.g. Rowney Rose. Oil painters usually stand (or sit) at an easel and work on primed canvas stretched over a wooden frame called a stretcher, or on wood or board panels. These can be prepared by the artist in various ways. Many amateurs buy ready-made canvas-covered boards, but it is better to take the time and trouble to prepare your own. Thickly applied paint requires stiff hog-hair brushes, and thin glazes of color are best applied with soft hair brushes such as sable. Mediums for glazing, increasing the drying rate, etc. are available from art stores, but there are many traditional recipes for mediums, varnishes, grounds, etc.

RIGHT Tubes of oil paint. These can be purchased as sets or singly. It is a good idea to buy a large tube of white.

BARBARA

Oil on canvas-covered board, 14 x 12in

R O S C U T H B E R T

Keeping the paint thin and working on a white ground, I aimed for luminosity and a fresh approach in this study of Barbara.

1 For this demonstration of painting in oils I chose a white ground. First, I decide on the size and position of the head, using viridian thinned with turpentine.

2 Then I explore the likeness and develop some modeling. For this, I use a mix of raw umber and burnt sienna and continue to work very thinly.

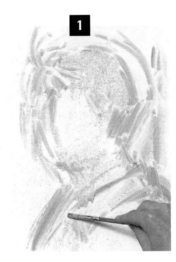

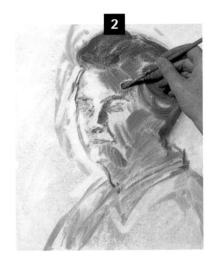

3 I brush in a background color of raw sienna and then begin applying the flesh tint, mixed with titanium white, cadmium red, and a touch of raw sienna and cobalt blue.

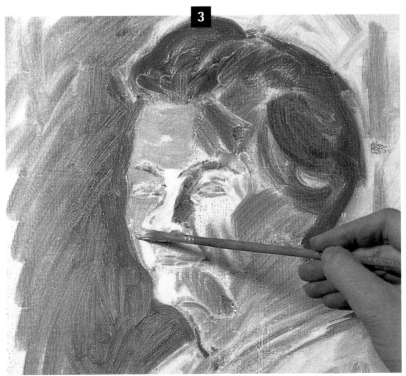

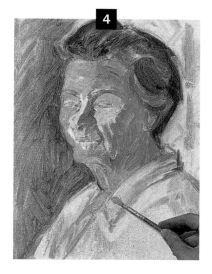

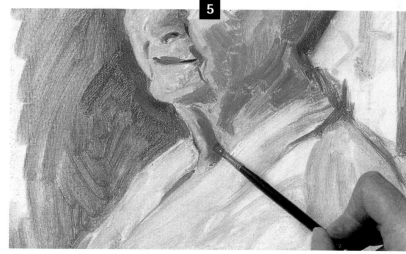

4 Still working broadly, I adjust the half tones using some of the flesh tint and adding more raw sienna and cobalt blue.

5 The features are strengthened and the expression caught using mixes of raw umber, carmine, cadmium red, cobalt blue, and white.

6 At this stage the likeness and the modeling are established but the treatment is still very rough.

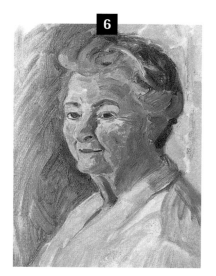

7 I further define contours and establish form adding a small amount of lemon yellow, cobalt blue, and carmine to some of the half tone areas, and using a rag from time to time as well as a brush to blend and make corrections.

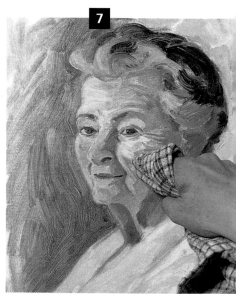

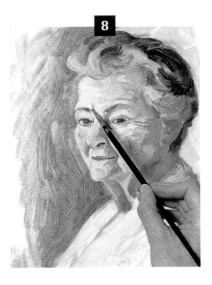

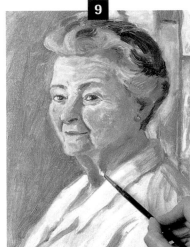

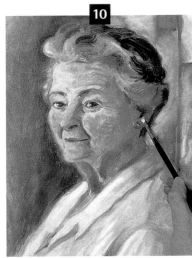

8 Lighter values are now added to the flesh tint using white, cadmium red, and lemon yellow. The cheeks and chin have been warmed by the addition of a little carmine.

9 The ear is touched in using a mixture of raw umber, cobalt blue, and cadmium red. Cheek and neck are further developed and white highlights are added to the eyes.

10 Using raw umber and burnt sienna, I deepen the background around the pale hair, face, and blouse, and add a final touch of light on the ear.

11 The final picture.

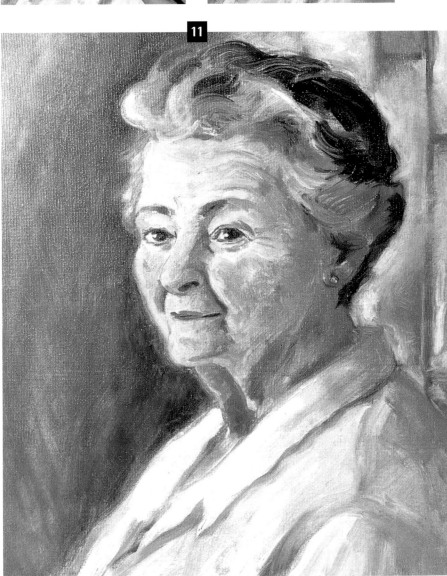

12

PHOTOGRAPHY AND

GROUP PORTRAITS

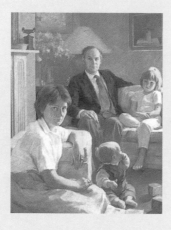

SINCE THE RENAISSANCE, ARTISTS HAVE SHOWN A CURIOSITY ABOUT TECHNICAL, SCIENTIFIC AND MEDICAL DISCOVERIES, SUCH AS THE CAMERA OBSCURA, A KNOWLEDGE OF ANATOMY, MATHEMATICAL PERSPECTIVE AND COLOR THEORIES, MAKING USE OF THEM IN THEIR WORK. THIS ACCOUNTS FOR MANY OF THE CHANGES IN STYLE WHICH HAVE HAPPENED OVER THE CENTURIES. EVER SINCE PHOTOGRAPHY WAS INVENTED ARTISTS HAVE MADE USE OF IT. IN ONE SENSE THE INVENTION OF PHOTOGRAPHY FREED ARTISTS FROM ILLUSIONISTIC PAINTING AND IN ANOTHER IT PROVIDED US WITH EXTRA MEANS. SOME ARTISTS THINK IT WRONG TO WORK FROM PHOTOGRAPHS, AND THAT WORKING FROM LIFE IS MORE HONORABLE. FOR ME THE ISSUE IS NOT ONE OF RIGHT AND WRONG BUT WHETHER IT IS APPROPRIATE OR HELPFUL.

I am sure that if photography had been invented in Leonardo's time he would have used it. Vermeer did, as we all know, use an early forerunner, the camera obscura. But this by itself was not responsible for enabling him to produce such marvelous paintings. He still had to compose them and paint them.

PHOTOGRAPHIC PROBLEMS

A few cautionary remarks are in order here though, as it is not as easy as one might suppose to paint a convincing portrait from a photograph. I would say that working from a photograph has every chance of *increasing* the difficulties. Photographs can suffer

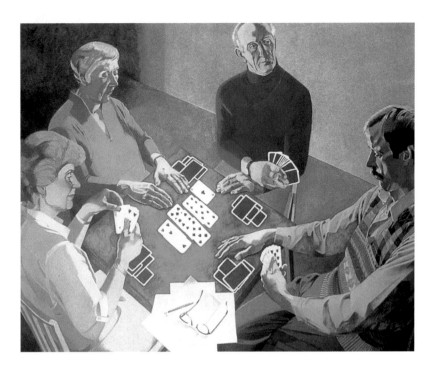

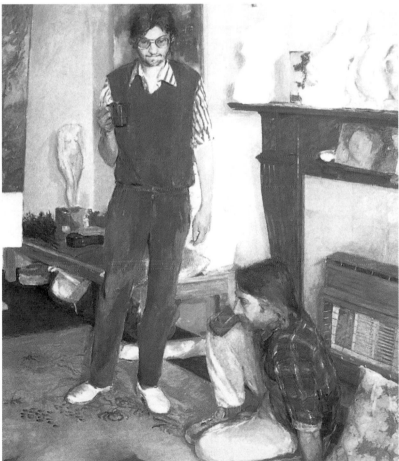

ABOVE Ivy Smith, T*he Bridge Party* (oil on canvas), 52 x 60in.
When Ivy uses photography she does so only to help generate ideas for a composition. She takes random quick "snaps" to catch people in movement and these give her ideas for poses. Then she makes careful, detailed drawings working from life. The painting is done in the studio from these drawings.

LEFT Linda Atherton, *Tea in the studio* (oil on canvas), 59 x 53in.
Painted from life on an acrylic ground, these figures are almost life-sized. On this scale the acrylic ground is not a success – the painting expands and contracts too much when moved from one venue to another.

OPPOSITE PAGE Juliet Wood, T*he Parker Family* (oil on canvas), 44 x 35in.
Juliet first made a composition sketch and took photographs for backup material.

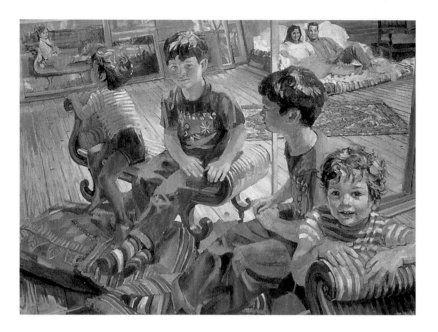

LEFT Anne Hicks, *Double Trouble*
(oil on board), 36 x 48in.
This group portrait was painted on a
mid-toned warm underpainting. The
mirror creates a sense of space and
shows different views of the children's
faces. A photograph was used for the
stripes on the boy's T-shirt.

BELOW Linda Atherton, *But I know what
I like* (oil on canvas), 74 x 80in.
This portrait was done from life over a
period of a year, the sitters coming
along when available. The elderly man
and seated lady had ten sittings each,
the other two had four. At certain
stages the sitters had to appear
together for the composition and skin
tones, to be checked. No photographs
were used.

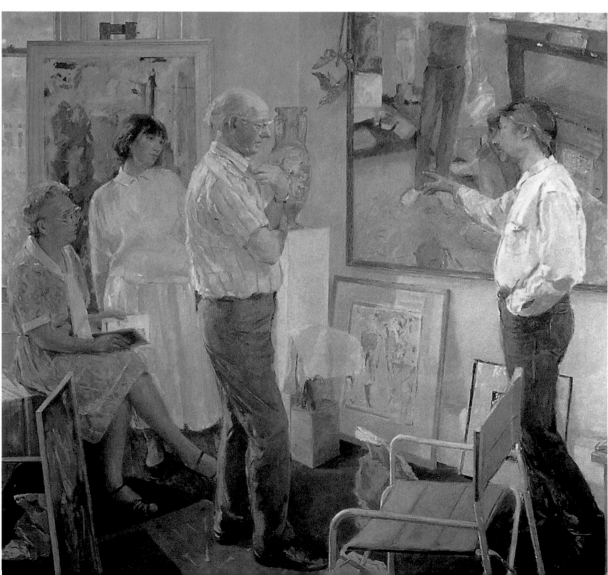

from ailments such as over-exposure, under-exposure, bad focusing, camera shake, inaccurate representation of colors, odd expressions which have nevertheless been fixed by the camera, etc. When my students come armed with a photograph from which they wish to paint a portrait I always look most carefully at the material and discuss these points first.

In general I do not recommend painting from photographs to inexperienced artists. It is much better to practice from life for various reasons. Firstly, the possible inadequacies of a photograph are difficult if not impossible, even for an experienced portrait painter, to correct because in the matter of a likeness you simply cannot paint what is not there. Secondly, the living sitter has a presence that no photograph has, and this presence gives atmosphere to a painting. Thirdly, the gradual development of a portrait takes place over hours or days, during which the sitter's mood will change as well as your own; the light will change; and you will have time to get to know your sitter. These variables give a portrait greater depth of feeling and insight. It is difficult to quantify such a thing. These are some of the reasons why people use words like "right" and "wrong"

Be that as it may, there are times when a photograph is all we have. One of my students used to spend his days happily painting from photographs of characters he met on vacation. The following year he would take them back and have an exhibition in the local bar. Another student of mine found it impossible to work from life. Whenever he did so his drawing

regressed to that of an eight year old. But working from photographs was a different story – he did marvelous pastels and had no difficulty with drawing. He was an engineer and had spent his life working on plans, and had no difficulty transcribing from one two-dimensional surface to another but simply could not see the third dimension to draw it. Very strange, but we are all different.

ADDED INFORMATION

Personally, I rarely use a photograph unless I am painting a commission where the subject is too busy to sit for very long. In that case I make sure I have at least one sitting when I draw and make composition studies, as well as discuss the portrait with the client. I then take photographs – usually a whole roll of film – from which I make selections at home. I often use six or more photographs for a single portrait. If they are good I can even do the whole portrait from them, but I like to insist on a

couple of sittings for the face, and to adjust any incorrect tone or color balance elsewhere. Over the years I have come to know what I need in the way of photographic material, and because I work mostly from life, can work fairly confidently from photographs. I take shots from different viewpoints even if I think I know what viewpoint I want, and also change the aperture setting to give a range of exposures. This gives added information about light and dark areas of flesh which may be lost in a single exposure setting if slightly under or over-exposed. I use a telephoto lens which cuts out perspective distortion. This can happen even with a standard lens if you go in too close for a detail of the face: the nose may end up looking very large, for example.

COMPLEX COMPOSITIONS

Once you have painted single figures for a while you may want to try a composition of two or more figures. Arranging figures together is not easy. Many group portraits are very dull because they are unimaginatively composed, or else unconvincing because of poor spatial relationships. It is worth simply making studies informally to gain ideas about how we look in groups. Taking a sketch book to a bar, a club, or the beach is a very good idea. When you have found a couple who will sit together for you, first draw them together several times (and take photographs if you wish). These could be simple "thumbnail" sketches or more complete studies. When you have found a composition to your liking you can proceed, but remember that adjustments are even more tricky where more than one figure is involved, so do be sure of your composition.

Photography is very useful in group portraiture. In the quiet of the studio ideas can be tried out without wasting your sitters' time. Once again, I try to get everyone together for a group drawing and photo session. From then on I may never see them all together again so I make sure I have plenty of material.

I once painted the bellringers at my neighborhood church. I went up on practice night to the church tower for months, just to draw and watch, and gradually decided that a group portrait might be fun. I took some photographs – rather inadequate ones as the lighting and lack of space made things very difficult – and asked the subjects to come one at a time to my studio to do the likenesses. I made a feature of the single fluorescent tube light and the antiquated electric fire.

A group composition should have a strong sense of pattern, of design, if it is to hold together. Vary the angles of faces and limbs to help the eye around the picture. A variety of light sources might also add interest.

LEFT Ros Cuthbert, *Winscombe Bellringers* (oil on canvas), 72 x 48in. This is still my biggest group portrait, a 13-figure composition.

13
UNUSUAL
PORTRAITS

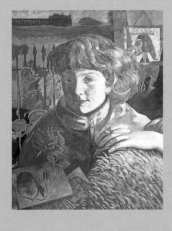

THIS CENTURY THE ATTITUDE OF MANY ARTISTS TOWARD PORTRAIT PAINTING HAS UNDERGONE PROFOUND CHANGES. IN THE FIRST DECADE PICASSO'S CUBIST PORTRAITS OF HIS LOVER FERNANDE OLIVIER RADICALLY REMADE THE GENRE. BESIDES THE CUBIST FRAGMENTING AND FACETING, THERE HAVE BEEN PORTRAITS IN STRIKING COLOR, AS IN MATISSE'S FUAVE PORTRAITS. HIGHLY IMAGINATIVE, EVEN BIZARRE PORTRAITS BY SURREALISTS, SUCH AS SALVADOR DALI AND FRIDA KAHLO, HAVE TAKEN US INTO THE REALMS OF FREUDIAN PSYCHOLOGY AND DREAM; WHILE IN THE ANXIOUS YEARS OF THE COLD WAR, FRANCIS BACON PRODUCED HIS SCREAMING HEADS AND TROUBLING SELF PORTRAITS. BUT THROUGHOUT THESE DISPARATE APPROACHES, NONE OF THE ARTISTS HAS AVOIDED THE CHALLENGE OF RENDERING A LIKENESS.

These great artists produced superb and extraordinary portraits but they were not portrait painters who had to earn their living by their trade. Rather, they used the motif of the portrait as a way of exploring processes of perception. Many lesser contemporary artists fall into this category and some straddle both, partly working to commissions but also working to satisfy a sense of curiosity or adventure.

RIGHT Helen Elwes, *The Green Woman – a self portrait* (egg tempera on board), 7 x 6in.
Helen finds that tempera lies somewhere between drawing and oil painting. She likes to use it for composition studies. In this portrait she sees herself in relation to Nature, connecting with the pre-Christian symbol of the Green Man.

BELOW Steve McQueen, *Bulimia* (acrylic on canvas), 30 x 60in.
In these three linked close-ups, the round spectacles distort the night cityscape, symbolic of the subject's disturbed state of mind.

PREVIOUS PAGE Ros Cuthbert, *Evening at Knightstone* (oil on canvas), 28 x 22in.
This portrait is based upon a photograph taken of my daughter when, one winter afternoon, we found ourselves waiting in a car by the ocean.

RIGHT Anne Hicks, *Children by the waterfall* (ink and gouache on brown paper), 36 x 24in.
Each afternoon, when the park supervisor was out of sight, Anne would take her children to this waterfall and paint them through the leaves.

IMAGINATIVE PROCESSES

A few years ago, I almost had the chance to paint the envoy of Britain's Archbishop of Canterbury, Terry Waite, but he was abducted in Beirut before the first sitting. While waiting for his release, I began drawing imaginary studies helped by photographs from the press. As time went by and he remained a hostage I began to conceive of a series of imaginary portraits. The project eventually grew to a series of more than 20 paintings – *Portraits of a Hostage*. Although a difficult time, it was very productive. I discovered how to combine imaginative processes with portraiture and this has been useful ever since – though I never got to paint Terry Waite himself.

ABOVE Ros Cuthbert, (left) *The Hostage – Bread*), **(right)** *The Hostage – Beans*, **and (bottom)** *The Hostage – Salt* **(all oil on canvas), all 24 x 24in.**
Three from a suite of six in which British envoy Terry Waite's head is portrayed with produce from the Lebanon.

I once painted a posthumous portrait, and would not wish to do so again. The request came early in my career from an old schoolfriend. Her best friend had died in a car accident. Could I do a portrait of her from photographs? The photographs turned out all to have failings of one kind or another, but I chose the least problematic and did my best with it. Needless to say the picture failed over the matter of the likeness. A painting of an ancestor is less awkward – if no one remembers him or her alive.

RIGHT Jerry Hicks, *Orlando* (oil on board), 18 x 12in.
This was painted as a joke for a friend and was one of several such "old master" ancestors, painted with the likeness substituted.

FANTASY PORTRAITURE

Talking of ancestors, it can be fun to play with your sitter's identity – this could be called fantasy portraiture and is very much a part of the history of the portrait. You could dress your sitter in historical costume and invent ringlets or a tonsure or whatever you wish, and even try painting in the manner of an old master, all for fun. Sometimes a sitter may suggest an unusual costume – harlequin or jester perhaps – or an historical character they would like to pose as. Portraiture can have a light-hearted, theatrical side.

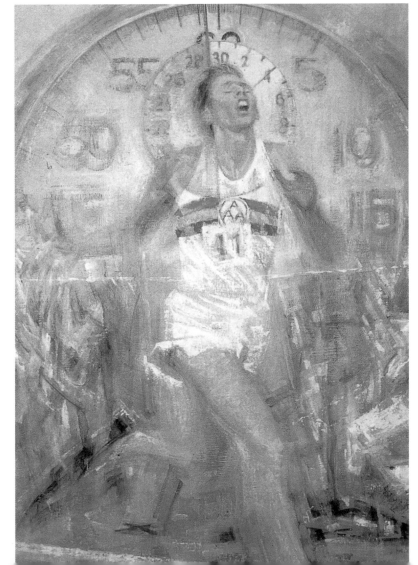

RIGHT Jerry Hicks, *Roger Bannister breaking the four minute mile barrier* (oil on board), 60 x 36in.
This portrait won a Queen's Silver Jubilee Award in Great Britain for a painting of a great British achievement.

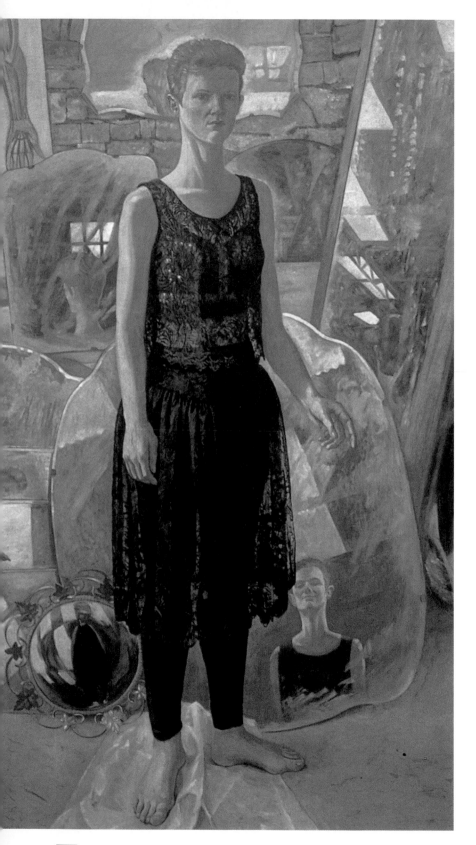

ABOVE Ros Cuthbert, *Self portrait on a coach* (oil on panel), 36 x 24in.
I used to spend a good deal of time traveling up and down to London to teach, and over a period of ten years made over 100 studies of bus passengers – in watercolors, colored crayon and even dry point. This self portrait was painted in the studio, the bus interior done from drawings.

LEFT Ros Cuthbert, *Self portrait with mirrors* (oil on board), 60 x 36in.
The pose was inspired by Goya's lovely painting of the Duchess of Alba. The mirrors are partly from photographs taken in a junkyard and partly from life, and the reflections are reinvented.

OPPOSITE PAGE Hugh Dunford Wood, *Family portrait* (acrylic on leather), 78 x 78in.
The family wanted this portrait painted on white tanned cowhide. The artist made drawings of the individuals first and built the composition from these, then he finished off with sittings.

SELF PORTRAITS

The self-portrait is a lovely opportunity for trying out more playful, whimsical ideas – no one will mind how you depict yourself. One of mine was partly inspired by Goya's beautiful portrait of the Duchess of Alba. I dressed up in black lace and painted myself from life, pointing at the floor in imitation of the portrait in which the Duchess stands pointing at the ground on which is scratched the signature of the artist. (In my portrait I point towards my bare feet standing on a piece of polythene.) The background too is very different. I had recently visited a junkyard and photographed a fascinating corner – a pile of old mirrors which reflected my passing image in all sorts of odd ways. I based the background on some of these photos, reinventing the reflections. Also at my feet is a convex mirror, a reminder of another wonderful portrait, Van Eyck's *The Arnolfini Marriage* (see page 7). At the top on the left, cut off by the edge of the canvas and by the mirrors, is a cutaway diagram of a man. His arm is visible with the fingers as if resting behind the mirrors. One push from him and the whole illusion topples!

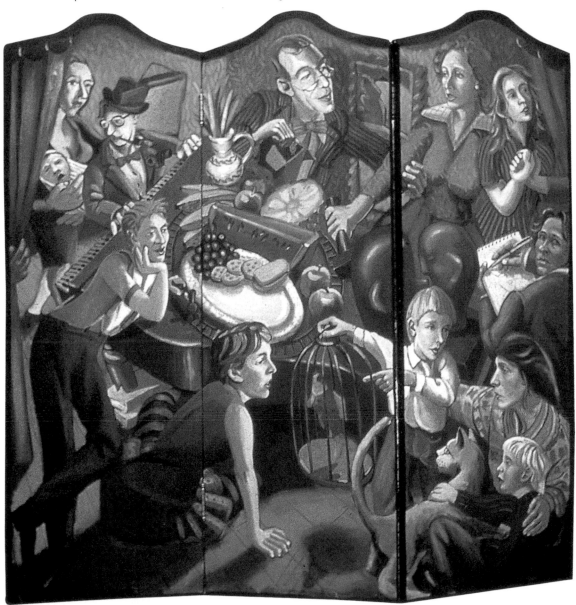

14

<u>COMMISSIONS</u>

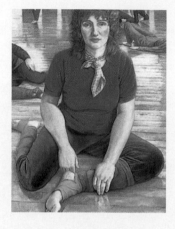

RECEIVING YOUR FIRST COMMISSION WILL NO DOUBT BE AN EXCITING EXPERIENCE. PERHAPS A SENSE OF PLEASURE WILL COMBINE UNEASILY WITH ANXIETIES OVER THE POSSIBLE OUTCOME. A FIRST COMMISSION IS A DAUNTING EXPERIENCE, BUT EVEN SOME EXPERIENCED ACTORS DECLARE THEY FEEL NERVOUS BEFORE A PERFORMANCE. IT IS GOOD TO KNOW THAT SOMEONE IS CONFIDENT ENOUGH IN YOUR ABILITIES TO WANT TO COMMISSION YOU. WHEN MONEY IS INVOLVED IT IS BEST TO BE BUSINESSLIKE FROM THE FIRST AND DRAW UP A CONTRACT. I HAVE HEARD ENOUGH STORIES OF COMMISSIONS THAT ENDED WITH BAD FEELING TO KNOW THIS IS IMPORTANT. DO NOT MAKE FRIENDS AND RELATIVES AN EXCEPTION. YOU CAN ALWAYS SAY APOLOGETICALLY THAT YOU NEED TO PRACTICE BEING BUSINESSLIKE.

If you are painting a stranger you will need to draw them for a morning or an afternoon and get to know them a little, and you will need to discuss their requirements before a contract can be agreed. Be sure to include in your discussion the medium of the painting, its dimensions, and an estimation of the number of sittings, as well as details about the kind of portrait they envisage. If they are content to leave decision-making largely to you, and in my experience they usually are, then let them know what you are planning before you do it.

I used to find one of the most difficult things about painting a commission was that the client might be very keen to monitor progress and want to see every stage of the painting process. While theoretically there is nothing wrong with this (and it is certainly preferable to lack of interest), a non-painter cannot necessarily understand that it is a searching process and their confidence may suffer if they see a chaotic-looking underpainting or a half-finished image that not only does not resemble them but is positively grotesque! Their anxiety may reflect

on your own confidence, even if you are quite experienced, and if you are worried about this you can always refuse to show it until it is near completion. Indeed, this is the practice of some portrait painters.

PAINTER'S AWARENESS

So, your client is finally sitting for you. Now comes the acid test for a portrait painter's awareness. Your sitter may want to talk while you paint, and may even expect you to reply. To have part of your attention on a conversation and the rest on your work is at times difficult. Do

RIGHT Ros Cuthbert, *Group Captain Cheshire and Lady Ryder* (oil on canvas), 39 x 27in.
This painting was commissioned by the National Portrait Gallery, London. I visited the Cheshires' home, where they sat for several studies in charcoal and pastel. I took a roll of photographs and planned the composition at home, returning a month later to paint the portrait, which I did from life in four days.

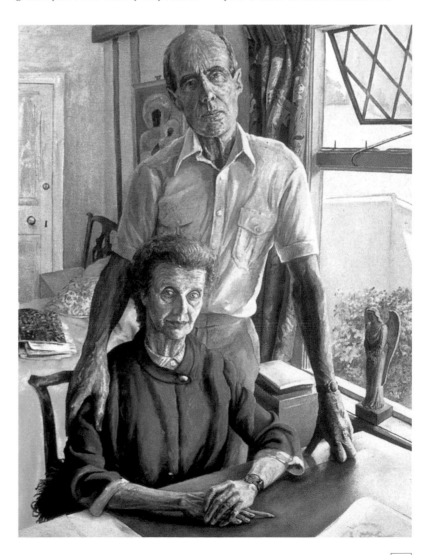

OPPOSITE PAGE Ros Cuthbert, *Judith at Bristol Dance Centre* (oil on canvas), 42 x 35in.
To prepare for this portrait I drew Judith at her dance class and took some photographs. From this material I planned the composition. Judith came about eight or ten times for sittings, and the background was done from photographs and drawings.

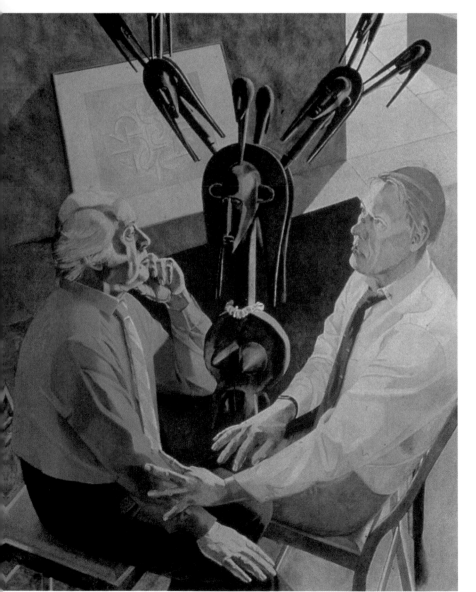

TOP LEFT Ivy Smith, *Studies for Attenborough Portrait – Sir Richard* (pencil), 22 x 30in.

TOP RIGHT Ivy Smith, *Studies for Attenborough Portrait – Sir David* (pencil), 22 x 30in.

LEFT Ivy Smith, *Portrait of Sir David and Sir Richard Attenborough* (oil on canvas), 60 x 49in.
This portrait was commissioned by the National Portrait Gallery, London, when Ivy won first prize in their annual competition in 1986. Although Ivy works directly from life for some portraits, for others she prefers to make detailed drawings from the sitter and paint these in the studio.

RIGHT Jerry Hicks, *Monty Flash and Family* (oil on canvas on board), 36 x 48in.
This painting was done from studies and photographs.

not worry – with practice it becomes easier. When I first learned to drive I could not possibly talk with a passenger while driving, but now I think nothing of it. It is just the same with a portrait. By the time you are halfway through your first sitting you will be able to say that while you are painting his mouth you need it to be still. I once painted a couple who were so garrulous that I painted them both with their mouths slightly open. It was such a characteristic of them that it could not have been otherwise. On another occasion a girl I painted was so full of fun we spent the afternoon laughing and joking – and I painted her smiling broadly. Most sitters are content to be passive but just occasionally a lively one needs special treatment. In fact, passivity can also be a problem, as it can lead to boredom or sleepiness. Keep a sharp eye on your sitter's comfort. Give him or her plenty of rest breaks and if necessary make them walk around outside to wake them up. Or start up a conversation. It is so difficult to paint the eyes of someone whose lids keep drooping. Children might like a story tape or even a television placed just behind your shoulder. Or a conversation: I have had some fascinating chats with my child sitters.

COMMENTS AND CRITICISM

When your portrait is almost complete, show the client and ask for comments. Then, if necessary, you can make adjustments. Do not make the mistake though of altering something you know is right, just to please them. I once scrubbed out a perfectly good mouth and replaced it with a less good one because of criticism. It might be better to let the sitter live with the picture for a week and then see.

Only once have I painted a commission that went down badly. At first the client seemed satisfied but when I met him later he said his friends thought I had made him look too old. I went to his home and had another look, but to my eye it was a good likeness. I apologized, but said I didn't think I could improve it. I hope by now (this was 15 years ago) he looks a little older than the portrait and all is well.

INDEX

INDEX OF ARTISTS ILLUSTRATED

ACKNOWLEDGMENTS AND PICTURE CREDITS

The Publishers are grateful to the following who attended sittings for the demonstrations in this book: Kurumi Hayter, Laura Forrester, Jaz de Mendoza, Angus Murdie, Ingrid Cole, Barbara Hyde, Domenico Iardella.

While every effort has been made on the part of the Publisher to acknowledge all sources and copyright holders, Quintet Publishing would like to apologize if any omissions have been made.

Additional credits: page 1 Robert Maxwell Wood; page 2 Juliet Wood; page 3 Jane Bond; page 34 Copyright of the Portrait of Julia Somerville is owned by Alexon International Ltd; pages 55, 71, 126 Portrait of Sir Richard and Sir David Attenborough from the Collection of The National Portrait Gallery, London.